MAN RAY

IN FASHION

INTRODUCTION BY

Willis Hartshorn
Merry Foresta

SPECIAL CONSULTANT

John Esten

Published in conjunction with the exhibition,
MAN RAY/BAZAAR YEARS: A FASHION RETROSPECTIVE

The exhibition, catalogue, and international tour are sponsored by
The Chase Manhattan Corporation and Hearst Magazines, a Division of The Hearst Corporation.

Additional support is provided by the National Endowment for the Arts.

INTERNATIONAL CENTER OF PHOTOGRAPHY
NEW YORK CITY

20 00 004 067

This catalogue is published in conjunction with the exhibition, *MAN RAY/BAZAAR YEARS: A Fashion Retrospective*, organized by the International Center of Photography, New York City, and on view at ICP Midtown from September 7 through November 25, 1990.

Distributed by the International Center of Photography
1130 Fifth Avenue
New York, NY 10128
(212) 860-1767

Designer: John Esten

Cover Design and Production Supervisor: Art Presson

Text editor: Robert Levy

Typesetting and Composition: Lee Goodman Design

Printed and bound in the United States by Northeast Graphics, Inc., North Haven, CT.

The International Center of Photography was established in 1974 to present exhibitions of photography; offer photographic education at all levels; preserve and study important 20th century images; and provide a forum for the establishment of standards, exchange of ideas and dissemination of information. ICP is chartered by the Board of Regents of the State of New York and accredited by the American Association of Museums.

PREFACE

When the International Center of Photography invited The Chase Manhattan Corporation and Hearst Magazines to co-sponsor *MAN RAY/BAZAAR YEARS: A Fashion Retrospective*, we were pleased to accept. ICP is the preeminent photography museum in the world, and we knew this exhibition would continue the institution's tradition of excellence in cultural and educational programming.

We were also enthusiastic about this particular show, which is the first to explore Man Ray's singular contributions to the field of fashion photography. His work for *Harper's BAZAAR* and other publications continues to influence the look and content of today's fashion magazines.

Finally, we saw this as an opportunity to explore a new approach to corporate support for the arts. The partnership of Chase and Hearst has allowed us to bring the combined resources of our corporations to bear on this exhibition. Our offices and operations around the world share our commitment to this project and are providing additional support in each of the cities on the exhibition's international tour. We hope that many of Chase's customers and Hearst's readers will see and enjoy the exhibition and will, in turn, offer support to ICP. We believe that such a partnership – of businesses with a strong belief in the importance of the arts in our society – can provide lasting benefits to cultural institutions and the public that extend far beyond the capabilities of most individual companies.

Both Chase and Hearst have enjoyed collaborating on this project. We salute the International Center of Photography and extend our thanks to the members of the museum's staff for all they have done to make the exhibition possible.

Michael F. Dacey
Executive Vice President
The Chase Manhattan Corporation

D. Claeys Bahrenburg
President
Hearst Magazines,
A Division of The Hearst Corporation

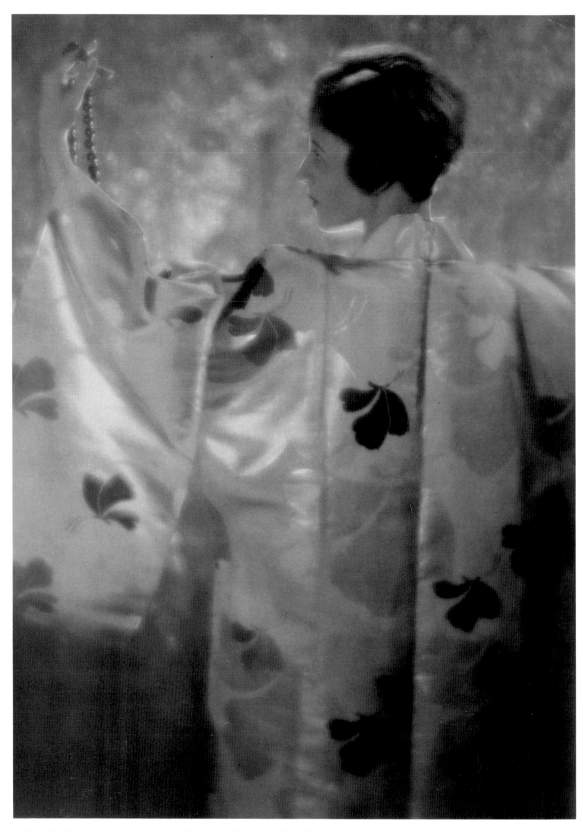

Untitled fashion photograph, dress attributed to Schiaparelli, c. 1925
Vintage gelatin silver print
Collection Timothy Baum, New York

ACKNOWLEDGMENTS

Partnership and collaboration have been essential to the realization of *MAN RAY/BAZAAR YEARS: A Fashion Retrospective*. For the past three years many people have given freely of their knowledge and it is their generosity that has made this project possible. Central to its success has been my colleague Merry Foresta, Curator, National Museum of American Art, Washington, D.C. As co-curator she shared years of research into the life and work of Man Ray that contributed immeasurably to the exhibition and catalogue. Also, John Esten, who as special consultant first brought this exhibition concept to ICP. His background as an art director at *Harper's BAZAAR* and his knowledge of the world of fashion and design have played a major role in the look of the exhibition and catalogue.

Mme. Juliet Man Ray's enthusiasm for the project was felt from the very start. She opened her home and archive and allowed us unlimited access to the works in her collection. The cooperation and efforts of Gregory Browner and the Man Ray Trust were also essential.

Lucien Treillard graciously shared, not only his extensive collection, but his insights into Man Ray, his friends and colleagues. Without Mr. Treillard's support and generosity this exhibition would not have been possible.

A special note of appreciation must be given to Jerome Gold, who from the beginning assisted in both the research and loan of works for the exhibition. It is because of his encouragement that this project achieved its current magnitude.

This project has also depended upon the generosity of the following individuals: Timothy Baum; Keith DeLellis; Ruth Mueller; Mario Valentino; Providence Alongni; Sidney Geist; John Saladino; Virginia Zabriskie, Zabriskie Gallery, New York; Antony Penrose, Lee Miller Archives, England; Mme. Katherine Join de Terle, Cons. Chef d'establissement, Musée de la Mode et du Costume, Palais Galliéra, Paris; Marion Meyer, Marion Meyer Gallery, Paris; Taki Wise, Staley Wise Gallery, New York; Mark Walsh, Yonkers, New York.

The following people provided indispensable research assistance and guidance throughout the length of the project: Annie Barbera, Bibliothécaire, Musée de la Mode et du Costume, Palais Galliéra, Paris; Robert Kaufman, Librarian, Costume Institute Library, Metropolitan Museum of Art, New York; Mark Piel, Librarian and Sharon Brown, Assistant Librarian, New York Society Library; Diana Edkins, Curator, Condé Nast Collection, New York; Harold Koda, Director, Design Laboratory, Fashion Institute of Technology, New York.

Additionally, special thanks go to Pierre Gassmann and Scott Hyde for their exceptional photographic exhibition prints; Theodore Feder of Artist's Rights Society Inc.; Julie Gallant of fotofolio, and Robert Levy, for his sensitive editing of

the introduction. Deep appreciation to Roberto Passariello and Richard McGinnis, for their gracious hospitality in Paris.

The exhibition and catalogue could not have been realized without the continuous support of the staff and trustees of the International Center of Photography. Particularly, trustees Anne Ehrenkranz and Gayle Greenhill, who were instrumental in securing sponsorship for the project. Also, Ann Doherty, Deputy Director for Development, whose counsel was invaluable from the beginning. Patricia M. Boustany, Exhibitions Assistant, who thoughtfully and diligently organized the details of the exhibition. Lisa Dirks, Curatorial Associate, who marshalled the disparate elements of this catalogue with great skill and enthusiasm. Art Presson, Exhibition Designer for his contribution to both the catalogue and exhibition. My sincere gratitude also goes to Cornell Capa, Executive Director; Charles Stainback, Assistant Director of Exhibitions; Phyllis Levine, Director of Public Information; Madeleine Vogel, Registrar; Phillip Block, Director of Education; Steve Rooney, Deputy Director for Administration; Anne Hoy, Curator; Marta Kuzma, Coordinator of Traveling Exhibitions; Chris Heindl, Production Manager; Peter Mallow, Preparator; Debbi Baida, Traveling Exhibitions Assistant; Alyssa Haywoode, Public Information Associate; Jana Strauss, Assistant Director of Development; Maria Matthews, Development Associate.

In conclusion, we, at ICP, want to recognize the sponsorship of the National Endowment for the Arts and express our gratitude to The Chase Manhattan Corporation and Hearst Magazines for their generous support of the exhibition, catalogue and tour. Special thanks go to Michael F. Dacey, Executive Vice President, The Chase Manhattan Corporation; Aubrey Hawes, Vice President, Director, Corporate Advertising and Promotion, The Chase Manhattan Bank; and Alice Zimet, Vice President, Cultural Affairs, The Chase Manhattan Bank. Also to D. Claeys Bahrenburg, President, Hearst Magazines; Gilbert Maurer, Chief Operating Officer, Hearst Corporation; George Green, President, Hearst Magazines International; Martin Schrader, Publisher, Harper's BAZAAR; and Charlotte Veal, Public Relations Director, Hearst Magazines. We also want to acknowledge Fred Schroeder, First Vice President, and Lee Anne Fahey, Account Executive, of Arts & Communications Counselors for their tireless work on behalf of ICP and the project.

It is with deep appreciation that I thank my wife Patty Martin and daughter Anne Hartshorn. Their patience, understanding and support have been herculean.

Willis Hartshorn
Deputy Director for Programs

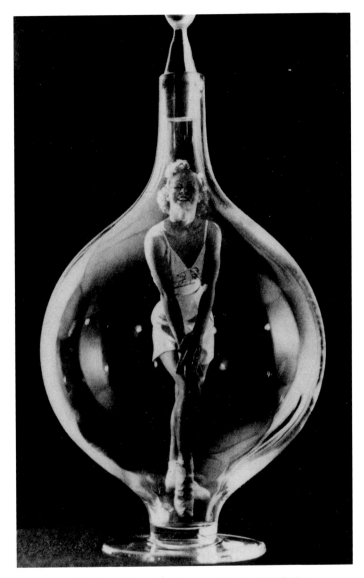

The Pulse of Fashion: Miss June Presser of the Ziegfeld Follies.
BAZAAR, January 1937
Photomechanical reproduction
Collection International Center of Photography, New York

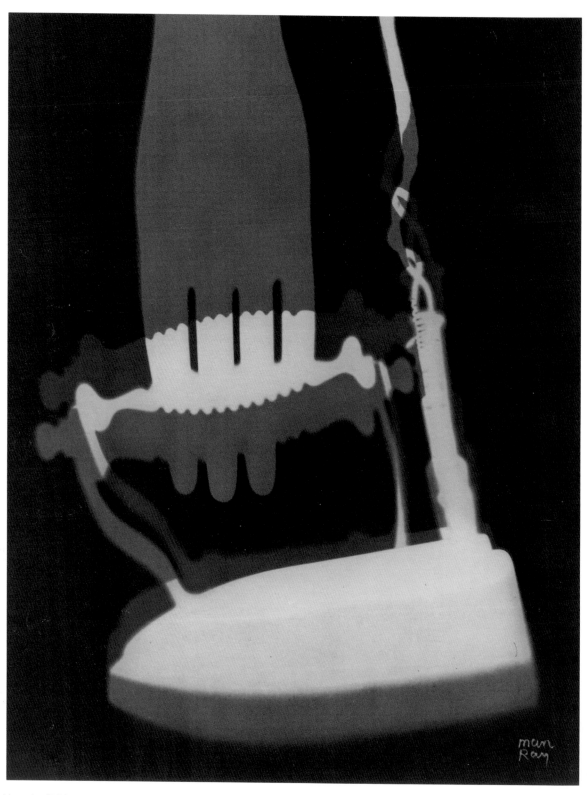

Lingerie, 1931
From the portfolio *Électricité*.
Photogravure
Collection National Museum of American Art,
Smithsonian Institution, Washington D.C.

MAN RAY
IN FASHION

One of the great ironies in discussions of Man Ray's art is how seldom the word "fashion" appears. In the long list of his accomplishments – as painter, photographer, object maker, filmmaker – Man Ray's role as a mediator of fashion invariably goes unmentioned. Yet, throughout his career, he clearly understood how the act of creative selection lifts the artistic gesture out of everyday life and identifies a style. Man Ray worked as a fashion photographer for *Vanity Fair*, *Charm*, *Vogue*, and *Harper's BAZAAR*, but he was equally a fashionable artist. From creating his own futuristic, glamorous-sounding name, out of the less evocative Radnitsky, to his life among the wealthy and famous, to his scintillating mix-ups of medium and genre, Man Ray established a modern method for making art.

When he arrived in Paris from New York in 1921, the American-born artist was already a celebrity to the young Dadaists. Neither wealth nor social standing gave Man Ray the connections that opened the way to success in Paris. He had earned his status from a decade of original, anarchistic activities in New York with Marcel Duchamp, Francis Picabia, and others.

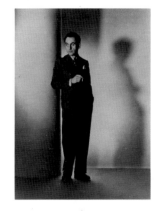

Self-portrait as fashion photographer,
c. 1936
Modern gelatin silver print from
copy negative
Private Collection

Accomplished as he was at the art of provocation, he had nonetheless begun his career conventionally around 1910 with canvas and paint, supporting himself through commercial drafting until leaving for Paris. He defied the critical art world by making paintings with a spray gun. He learned photography, publishing some of his efforts in Francis Picabia's journal *391*, and in the only issue of *New York Dada*. These established his fame well ahead of his European arrival.

Man Ray's artistic activity was predicated on a twofold system – one part ideal, the other circumstantial. He believed in Art, but equally in the practical; he was quick to use whatever source or method was at hand to do the job. Wielding a medium of such varied capabilities as photography, Man Ray willingly abandoned old ways in favor of new. In Paris this American shamelessly practiced Yankee ingenuity: by turning creativity into profit, the visionary artist was able to pay the bills. In the midst of the cultural pluralism that was Paris in the '20s, Man Ray's photography satisfied the avant-garde's quest for modernity.

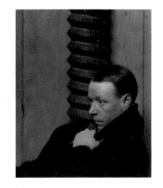

Sinclair Lewis, c. 1926
Modern gelatin silver print
Collection Juliet Man Ray, Paris

By the time of his first Paris exhibition in December 1921, six months after his arrival, Man Ray had started the portrait photography business that brought him growing celebrity and a stream of famous sitters – Henri Matisse, Pablo Picasso, Sinclair Lewis, Gertrude Stein, and James Joyce. A workman open to every possibility, Man Ray mined the vein of popular culture.

Through Francis Picabia's first wife, Gabrielle, Man Ray met the couturier Paul Poiret in 1922 and began taking commercial photographs for him. Man

Ray guessed the formula of fashion right from the start: "...line, color, texture, and above all, sex-appeal..."[1] It didn't escape Man Ray that the designer expected him to make "...something original...different from the usual fashion pictures."[2] It was not inconsequential to him that Paul Poiret, who counted Francis Picabia among his childhood friends, collected the works of the more advanced artists. Man Ray posed his model wearing Poiret's peacock tailed dress alongside a sleek metal bird sculpture by Constantin Brancusi. The texture and line were supplied by the couturier's dress and the artist's sculpture, but the titillating conjunction of art, female, and fashion was Man Ray's idea.

Sexy too were the Rayographs. These photograms of gears, darkroom equipment, crystals, and outlines of hands and faces blend irreverent machine-age art with stylish composition. Enthusiastically endorsed as "dada photographs" by Tristan Tzara, dubbed "paintings with light" by Jean Cocteau, the Rayographs were first purchased by Paul Poiret. Frank Crowninshield, editor of *Vanity Fair*, published four in the November 1922 issue. Titled "A New Method of Realizing the Artistic Possibilities of Photography," the page included a photograph of Man Ray along with reproductions of his namesake creations. In the first issue of *La Révolution surréaliste*, December 1924, J.A. Boiffard and company would declare that "fashion will be treated according to the gravitation of white letters on nocturnal flesh." Man Ray's work was no less ethereal, only more accessible. In his art, his fashion photography, and as a celebrity, Man Ray made it clear that he and his work were one.

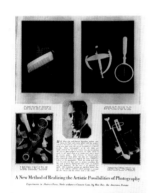

A New Method of Realizing the Artistic Possibilities of Photography.
Vanity Fair, November 1922
Photomechanical reproduction
Collection International Center of
Photography, New York

The dichotomy of Man Ray's life, his activities in the world of the Parisian avant-garde and his work as a commercial photographer, sometimes came together in very visible ways. He enjoyed social events such as the Comte Etienne de Beaumont's ball of June 1924, which followed the opening of *Les Soirées de Paris*, a series of theater and ballet performances sponsored by the Comte. The series included the ballet *Mercure* with sets and costumes by Picasso, Jean Cocteau's production of *Romeo and Juliet*, and a performance of Tristan Tzara's play *Mouchoir des nuages*. For the costume party, guests expended enormous creative effort on elaborate dress that – as we know from Man Ray's photographs – ranged from Picasso's toreador costume to Nancy Cunard's brocade pants suit and top hat, to Sara and Gerald Murphy's silk versions of cubist paintings. Similarly, the Futurist Ball, held by the Vicomte de Noailles and his wife Marie-Laure in 1927, to celebrate the redecoration of their home by designer Jean-Michel Frank, was full of photographic opportunities. Man Ray's photograph of his hostess suggests the flamboyance of the evening. Against a wall papered with pale parchment, Marie-Laure stands costumed as a squid, her gown and matching hat made from layers of speckled sharkskin.

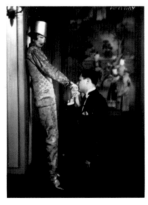

Tristan Tzara and Nancy Cunard at the
Beaumont Ball, 1924
Modern gelatin silver print from
copy negative
Private Collection

The Bal Blanc given by the Comtesse Pecci-Blunt captivated readers of French *Vogue*'s August 1930 issue. Man Ray's photographs of the guests, costumed in white – including one of the Vicomtesse de Noailles, and designers Christian Bérard and Jean-Michel Frank, dressed in togas in a Greek tableau – illustrated the accompanying text. The highlight of the party, organized by

Man Ray and his assistant, Lee Miller, consisted of having hand-colored film by the pioneer French filmmaker, Georges Mélièis, projected on the white-garbed couples on the dance floor.[3] As the many invitations Man Ray received following this evening attest, an artist able to imaginatively blend the worlds of art, fashion, and society could be very popular. The pragmatic Man Ray also understood that through such social opportunities came income, which bought time for making art.

While the wealthy controlled the fashionable world, a new breed of celebrity – the artist – was being created for public consumption. The avant-garde, for all its outrageous affronts to polite society, gave the everyday world what it wanted: originality based on non-conformity. Lining themselves up to be photographed, the Dadaists in their *Belle Époque* haberdashery revealed their vanity: spats and canes, felt gloves and snappy fedoras. Foppishly out of style, they celebrated the arrogance of modish elitism, the powerful conspiracy of toppled conventions. Their allure was their audacity, which their audience admired, but did not dare imitate. This same strategy animated Man Ray's 1921 photograph of Marcel Duchamp as *Rrose Sélavy*. Coquettishly posed, framed by an elegant *chapeau*, the "face" of *Belle Haleine, Eau de Voilette* was destined to become *New York Dada*'s cover girl. Both Man Ray and Duchamp understood that mass culture was fertile ground for the modern artist, a source for ideas as well as a vehicle for disseminating the artist's persona to a larger public.

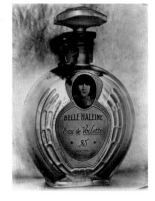

Belle Haleine, Eau de Voilette, 1921
Man Ray and Marcel Duchamp's creation for the cover of the one-issue magazine *New York Dada*.
Modern gelatin silver print
Private Collection

With up-to-the-minute articles and international editions, mass circulation magazines provided a transatlantic link between Paris and New York. The post-World War I atmosphere of renewed intellectual excitement infused articles and advertisements, allowing for the interaction of disciplines previously thought incompatible. In their pages, magazines could represent art, industry, literature, architecture, science, music, and theater all at once. Man Ray provided photographs for a number of illustrated publications including *Vu*, *Paris Magazine*, *Variétés*, *Jazz*, and *L'Art Vivant*. The cultural message spread to fashion magazines as well, where receptive editors and art directors not only reported the latest trends, but borrowed from the modernist sensibility to add vitality and cachet to their pages. It was a mutual attraction – besides Man Ray, artists such as Jean Cocteau, Salvador Dali, Brassaï, and Maurice Tabard were drawn to the magazines.

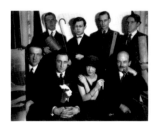

The Dada Group, November 1921
Back row (l. to r.): Paul Chadourne, Tristan Tzara, Philippe Soupault, Serge Charchoune; front row (l. to r.): Paul Éluard, Jacques Rigaut, Mick Soupault, Georges Ribemont-Dessaignes.
Modern gelatin silver print from copy negative
Private Collection

Between the wars, magazines mirrored the changing social structure, diversifying their reporting to include the wider category of culture – political and artistic; high and, at times, low. Carmel Snow, editor of *BAZAAR* during Man Ray's tenure with the magazine, wanted her readers not only to dress well, but to have "well dressed minds . . . It is not by chance," she declared, "that *BAZAAR* publishes fiction and articles on travel and theatre and movies and music in its pages. All these go to make up the climate of fashion and to be in fashion one must be very aware of the weather."[4] *BAZAAR*'s readers were exposed to an ever-expanding world of notable people and events, and, at the center, was Man Ray the image-maker, creating the most sought-after portraits of the newly, and soon to be, famous.

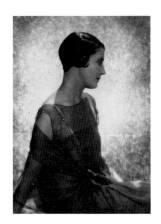

Daisy Fellowes, c. 1925
The Honorable Mrs. Reginald Fellowes,
member of the Parisian *haute-monde*
and Paris Editor of *BAZAAR* during
the 1930s.
Vintage gelatin silver print
Collection Lucien Treillard, Paris

Publications such as *BAZAAR*, *Vogue*, and its more highbrow cousin, *Vanity Fair*, defined "style" and "chic" for the magazine-reading public. On their pages our modern-day concept of celebrity was born. Through the '20s and into the '30s, the career of professional fashion model did not yet exist. Rather, it was primarily photographs of well dressed wives and daughters of socially prominent families that graced magazine pages.

Throughout the '20s, Man Ray's work was passed back and forth from Europe to America, from literary audiences to the *haute monde*, from artists to fashionable American women. His paintings, drawings, and photographs were reproduced in a variety of small journals such as *Broom*, *Dial*, and *The Little Review*. His portraits of artists, writers, and social celebrities appeared frequently in *Vanity Fair* and the Bamberger Department Store's *Charm*, a surprisingly chic publication. Articles that paired his photographs of socialites, artists, and artists' models with texts by such vanguard writers as Djuna Barnes and Mina Loy, as well as Alexander Archipenko or Maurice Ravel, helped catalog the style of an era.

Man Ray worked for the magazines, but he also made sure the magazines worked for him. As his portrait files grew, his talents were increasingly in demand by magazines desiring portraits of fashionable artists or popular socialites. In turn, the rich and famous found increasing reason to have their portraits made by a photographer whose work regularly appeared in stylish publications like *Vanity Fair* and *Charm*. While most artists suffered during the Depression, Man Ray made more money than he ever had before or would again. Like many of his clients, he sported suits tailored in London, drove the latest model Voisin, and owned a house in the country.

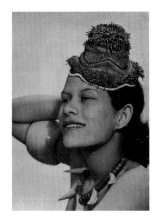

Adrienne Fidelin modeling African hat.
BAZAAR, September 1937
Photomechanical reproduction
Collection Juliet Man Ray, Paris

Man Ray shared his good fortune with artist friends and lovers, including them whenever possible in his fashion work as collaborators and models. Nusch Éluard, the elegant, slim wife of the poet Paul Éluard, often served as Man Ray's model, both for *BAZAAR* and for more personal images. For the September 1937 issue, he arranged for Paul Éluard to review an exhibition of African hats at the surrealist gallery of Charles Ratton. Man Ray's girl-friend, Ady Fidelin, modeled one hat about which the accompanying caption reported, it "will surely have a happy influence on fashion." This was the only magazine article for which Man Ray was allowed to use his Haitian lover as a model; her mulatto coloring prohibited her from receiving most couture assignments.

To the delight of the Surrealists, magazines took culture and put it on the newsstands. Photomechanical reproduction turned art into a product to be consumed, like food or clothes. Conversely, fashionable Surrealism could also be used to mock the fashion magazines themselves, or play an even more complex role in the surrealist debate. Man Ray's work could serve both ends.

The August 15, 1925 issue of Condé Nast's newly inaugurated publication French *Vogue* featured several pages of Man Ray photographs taken at the Pavillion de l'Elegance at the Grand Palais, part of the huge *International*

Exposition des Arts Décoratifs et Industriels Modernes. The pictures were of fashionably attired wooden mannequins, posed in a variety of staged, elegant interiors. The exposition's planners hoped the arrangement would exemplify the different conceptions of modern art. While the article in French *Vogue* was meant to document the clothes designed by Paul Poiret, Lucien Lelong, Louise Boulanger and others, the claim to art's fashionability was first appropriated by the Surrealists for their own ends.

One of Man Ray's pictures, which had been commissioned by French *Vogue* and would run in that magazine the following month, appeared on the cover of the July 5, 1925 issue of *La Révolution surréaliste*. The Surrealists accompanied the image with the caption, "And War On Work." Do the image and words together declare war on the mass production of a bourgeois culture? Or against the elitism suggested by one-of-a-kind fashion? Or only on the numb support of style suggested by the photographs of nonhuman models?

The answer may have been provided, though unknowingly, by French *Vogue* itself. Its article about the exposition's display designer, *"Siegel a crée une formale nouvelle dans l'Art du mannequin"* ("Siegel has created a new form in the Art of the mannequin"), suggests not only that modern art can best be seen against the background of style and fashion, but that the modern woman, *la femme d'aujourd'hui*, is most useful to fashion when most pliant and object-like, shaped of wood and wax. The ambiguity between the artificial and the real world symbolized by the mannequins worked as well for fashion as it did for the surrealist revolution.

It was this blend of conformity and individuality that, in fact, distinguished Man Ray's fashion photographs. The look is spare, modern, without fuss, but not without irony. The expression on the model's face is of minor importance compared to the line of the dress or the fold of the draped fabric. Though other photographers such as George Hoyningen-Huene, Cecil Beaton, or Horst would add surrealist props like broken columns to their pictures,

La Révolution surréaliste, 15 July, 1925
Photomechanical reproduction
Collection Timothy Baum, New York

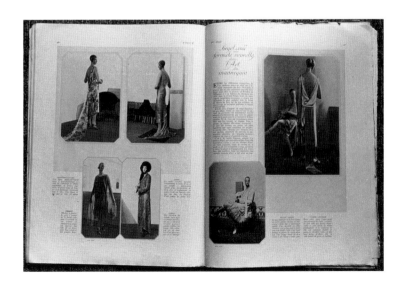

French *Vogue*, 21 August, 1925
Modern gelatin silver print from
copy negative
Courtesy Musée de la Mode et du
Costume, Palais Galliera, Paris

Man Ray's sets were, for the most part, empty. For dramatic effect he preferred to manipulate light and shadow. Later he would say that color photography was not to be trusted, and, at least in part, he was really noting his preference for the mysterious power of stark, black and white contrasts.

Rejecting surrealist settings for his fashion photographs, Man Ray instead placed his models against plain backdrops. If a setting was required, he preferred his own studio containing his own works of art or those of friends like Alberto Giacometti or Oscar Dominguez. He directed his fashion sittings like a cinematographer: Stand here, hold your arm there, higher, bend at the elbow, set your hand just so. Not until the picture was published would the model realize that such contortions had little to do with her, but rather with the motif of curves, from hand to dress to the Giacometti birds on the wall. Man Ray's models never look out longingly or defiantly at the viewer; in fact, at times headless in the final photograph, they are denied expression completely. Man Ray did not merely describe fashion; he was able to suggest its mystery. Neither still lifes nor staged dramas – certainly never portraits of the models – Man Ray's fashion photographs articulated the formal concerns of a commercial style while suggesting the more intricate realm of his own personal creativity.

Modern fashion had to be presented in a modern way. Techniques that had won over the avant-garde a decade before were cleverly reprocessed by Man Ray and the magazines for a larger audience in need of novelty rather than revolution. For example, in "This Young Grey Head," attempting to suggest the attractiveness of grey hair on a young woman, Man Ray solarized the profile of a young, well-coiffed beauty. "Beauty in Ultra-Violet," utilizes photographic technique to convey something wondrous, an extraordinary halo of light. A Rayograph serves to illustrate sheer stockings, and the same technique is used in the wavy illustration of "Fashions By Radio," which was Man Ray's photographic impression of a new fashion "coming over" the short wave. Defying materiality in this photograph, fashion's far reaching effects were best created by the shadowy forms of a darkroom magician.

Man Ray's methods were extreme. Models were decapitated; hands were separated from bodies; camera distortions made arms look long, and angular gestures seem more like contortions than sophisticated poses. The clothes were never as interesting as the pose to Man Ray; his surrealist preference was always for the nude. Not surprisingly, many of Man Ray's fashion-oriented images proved unsuitable for popular magazines. Many were subversive. While women were regularly treated as objects in the world of fashion, Man Ray's private work took this aspect of manipulation to extremes. For example, he photographed for William Seabrook, the travel writer and avowed misogynist, a woman's necklace that had been deliberately fashioned to be painful to wear. With explicit reference to the Marquis de Sade, women in Man Ray's photographs were frequently tied up. Their hands, breasts, and lips were often the focus of fetishistic appreciation. Isolated, depersonalized, the images were made all the more shocking by the same meticulous attention to studio lighting and posing that Man Ray exhibited in his fashion work.

This young gray head. The glamour is spectacular in a way that the bewigged ladies of the eighteenth century understand very well. The secret is simple. White hair, lavender rinsed.
BAZAAR, February 1937
Photomechanical reproduction from solarized photograph
Collection Juliet Man Ray, Paris

Marjorie Seabrook with necklace attributed to fashion designer Jean-Charles Worth, c. 1930
Vintage gelatin silver print
Collection Juliet Man Ray, Paris

By the late 1930s, however, the stylish elements of Surrealism, if not its spirit, had been completely absorbed by the fashion magazines. There was a uniformity to the mannequins, masks, and broken columns strewn about the surrealist wastelands assembled in the Paris or New York studios of *Vogue* or *BAZAAR*. Jewelry and accessories were photographed on dismembered hands and wrists. Amorphous sections of models were highlighted in dark, shadowy sets. In part, such imagery reflects the contact between designers, such as Elsa Schiaparelli and Coco Chanel, with the most prominent artists of Paris. It also suggests that Surrealism, by its very survival, had attained a permanence worth copying.

It was also the ability of a free-market economy to absorb the vanguard styles of the period and turn them toward commercial ends. As Dr. M.F. Agha, art director of *Vogue*, observed, "What is a snobbish art scandal today, is an accepted style tomorrow, and a merchandised style the next day. Look at all the carpets with Cubist designs, and bookends of Futurist inspiration that you find in department stores."[5] Man Ray noted the migration of art into fashion with characteristic irony and pragmatic enthusiasm: "Extraordinary results were expected of me, but I soon discovered that editors were more interested in using my name than in a new idea or presentation. If they expressed hesitation as to the advisability of using one of my far-fetched works, asking for a reduction in my fee, I replied to soothe my hurt vanity that in that case the fee would be double."[6]

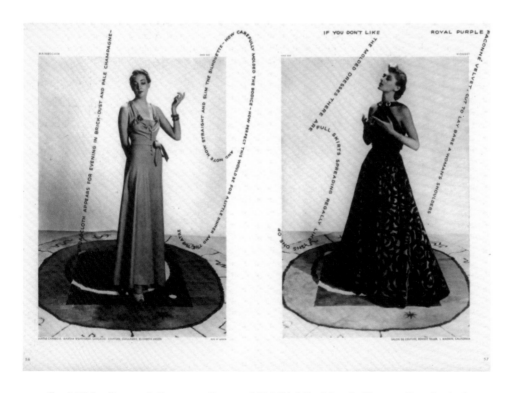

1937
BAZAAR, April 1937
Photomechanical reproduction
Collection Juliet Man Ray, Paris

In 1932, Carmel Snow, editor of *BAZAAR*, hired Alexey Brodovitch as the magazine's art director. As a young designer, Brodovitch had arrived in Paris one year before Man Ray, and for 10 years they shared the same artis-

tic milieu. Brodovitch brought Man Ray to *BAZAAR* – where he did his most important and innovative fashion work – along with Brassaï, Henri Cartier-Bresson, W. Eugene Smith, and the illustrator A.M. Cassandre. In an early design manifesto, "What Pleases the Modern Man," Brodovitch could well have been describing Man Ray: "The publicity artist of today must be not only a fine-craftsman with the faculty for finding new means of presentation but he must also be a keen psychologist. He must be able to perceive and preconceive the tastes, aspirations and habits of the consumer-spectator and the mob. The modern publicity artist must be a pioneer and a leader, he must fight against routine and the bad taste of the mob...We are learning to see and to feel new images, we are using new tools to work new materials: new and unexpected possibilities are opened up and a new aesthetic is born. This is an achievement. To deepen this achievement is the problem of the publicity artist."[7]

With the onset of the Depression, many little magazines published by artists, which had kept the dialogue between Europe and America going, ceased publishing. With only fashion magazines to count on, Man Ray decided to publish a book of his own in order to disseminate his work and the complicated hybrid of fashion and art that he had created. Assembled in France, but published with English text, *Photographs by Man Ray, 1920-1934*, an album of 105 photographs, was a sampling of the last 10 years of portraits, nudes, Rayographs, and solarizations that was meant to re-acquaint America with Man Ray. The publication included texts by Man Ray, Tristian Tzara, Marcel Duchamp, André Breton, and Paul Éluard, with titles like, "The Age of Light" and "Men Before the Mirror." Introduced by Breton's "The Faces of Woman," the section of female portraits and posed figures, many of them solarized, could easily have been a portfolio presentation at *BAZAAR*. Indeed, several of the images had already been published commercially.

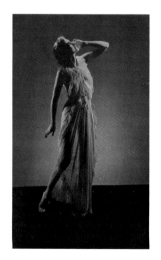

Le sex appeal, 1937
From the portfolio *Photographie n'est pas l'art.*
(Photography Is Not Art)
Photogravure
Collection Timothy Baum, New York

It became increasingly clear, however, that Man Ray's reputation in America as a fashion photographer had overshadowed his acceptance as an artist. Creative individuals who moved successfully in commerce were not to be trusted. Man Ray's 1936 collaboration with André Breton, *Photography n'est pas l'art* (Photography Is Not Art) spoofs critics who had difficulty accepting photography's ambiguous nature as a tool of both science and art. Included in the small pamphlet – among images of insects, an abstract detail of a notebook, and mating frogs – are two fashion pictures. One of lingerie is straightforwardly titled "Le sex appeal;" the other, depicting a tree with fruit wrapped against cold weather, is ironically captioned, "New Winter Fashions." A photograph's exactness was always open to interpretation. However, according to Breton and Man Ray, photography, because of its pliability was *not* art, because art was too rigid, its boundaries too narrow.

For Man Ray, it was a troubling realization that the power of the printed page had disseminated his reputation as a photographer faster than he was able to build his reputation as a painter. Through the '30s, the taint of the commercial world on his artistic reputation increasingly concerned him. Solicited by fashion magazines rather than art galleries upon his return to

America in 1940, he grew determined to renounce photography for the higher, though financially uncertain, rewards of painting.

The avant-garde ideals that fostered an intense period of interaction between art and commerce in the two decades between the wars were destroyed. Dispersed by the advancing German army, the men and women who together in Paris had created a stylish culture of interdisciplinary interests never regained the spirit of collaboration. Man Ray's expansive definition of art, the revolution of high and popular culture that the avant-garde had signaled at the beginning of the century, had not taken hold as he, and they, had hoped.

Man Ray's fashion photography represents the successful cross-fertilization of images both aesthetic and commercial. It is not surprising that he accomplished much of his best personal work in painting, photography, and film during the period when his commercial efforts were in greatest demand. While he pursued fashion photography because of a pragmatic need for money, he entered the world of fashionable society because of enthusiastic curiosity. As an artist, he was intricately involved in fashioning the world in which he worked. Unlike many of his subjects, Man Ray wore no costume; he openly brought his innovative, avant-garde ideas to his work in fashion. For a moment, fashion followed art and art worked with fashion.

This symbiosis, however, only worked briefly. Increasingly pressed to choose by critics at home, Man Ray was not prepared to sacrifice his art to fashion. Only now, in our media-rich time, has his work come to be seen as he would have wished – complex, multilayered, and reflecting the most advanced ideas of his time and culture.

<div style="text-align: right">

Merry Foresta and Willis Hartshorn
Curators

</div>

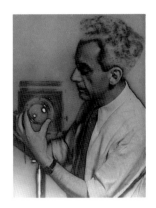

Self-portrait, 1932
Modern gelatin silver print from solarized negative
Collection Lucien Treillard, Paris

1. Man Ray, *Self Portrait* (New York: Little, Brown and Company Inc., in association with the Atlantic Monthly Press, 1963/1988), p. 105.

2. Ibid.

3. For further information on Lee Miller:
Livingston, Jane, *Lee Miller Photographer* (New York: The California/International Arts Foundation and Thames and Hudson Inc., 1989).
Penrose, Antony, *The Lives of Lee Miller* (New York: Holt, Rinehart and Winston, 1985).

4. Trahey, Jane, ed., *Harper's BAZAAR* (New York: Random House, Inc., 1967), p. 90.
Also see:
Snow, Carmel, with Mary Louise Aswell, *The World of Carmel Snow* (New York: McGraw-Hill Book Company, Inc., 1962).

5. Agha, M.F., "Surrealism and the Purple Cow," *Vogue*, November 1, 1936.

6. Man Ray, *Self Portrait* (New York: Little, Brown and Company Inc., in association with The Atlantic Monthly Press, 1963/1988), p. 237.

7. Brodovitch, Alexey, "What Pleases the Modern Man," *Commercial Art*, August 9, 1930, p. 69.
For further information on Alexey Brodovitch:
Grundberg, Andy, *Brodovitch – Masters of American Design Series* (New York: Harry N. Abrams Publishers, Inc., 1989).

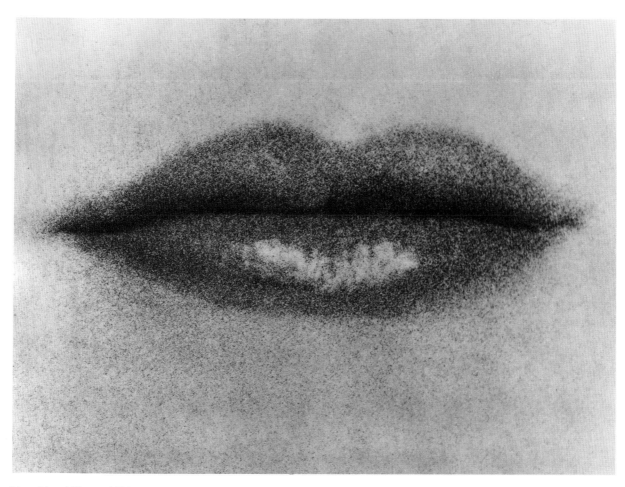

Lips of Lee Miller, c. 1930
Modern gelatin silver print
Collection Lucien Treillard, Paris

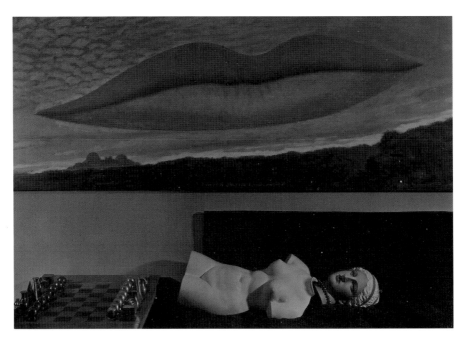

Plaster cast in front of *L'Heure de l'observetoire, Les amoureux*, 1934
(Observatory Time - The Lovers)
Vintage gelatin silver print
Collection Juliet Man Ray, Paris

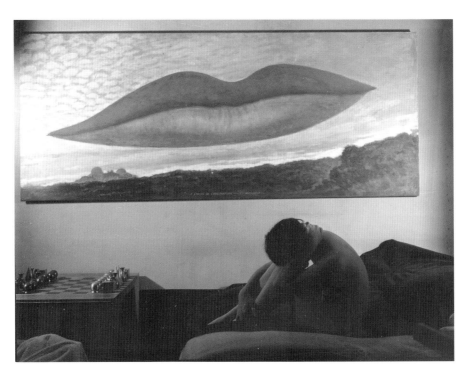

Nude in front of *L'Heure de l'observetoire, Les amoureux*, 1934
Modern gelatin silver print
Collection Juliet Man Ray, Paris

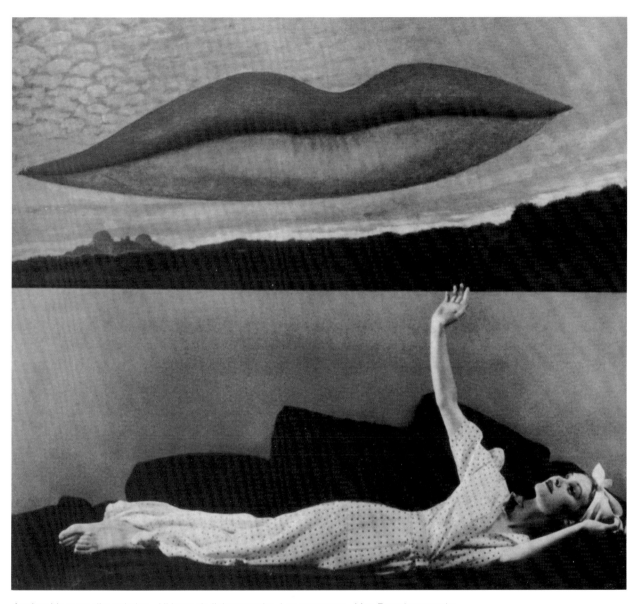

Against his surrealist painting - L'Heure de l'observetoire, Les amoureux - Man Ray photographs
a beach coat by Heim of white silk painted with little brown foxes.
Modern gelatin silver print from copy negative
Published in *BAZAAR*, November 1936
Private Collection

The Red Badge of Courage.
Editorial feature illustrating the application of lipstick as
"woman's gesture of courage in moments of stress."
BAZAAR, November 1937
Photomechanical reproduction with color added
during the off-set printing process.
Collection International Center of Photography, New York

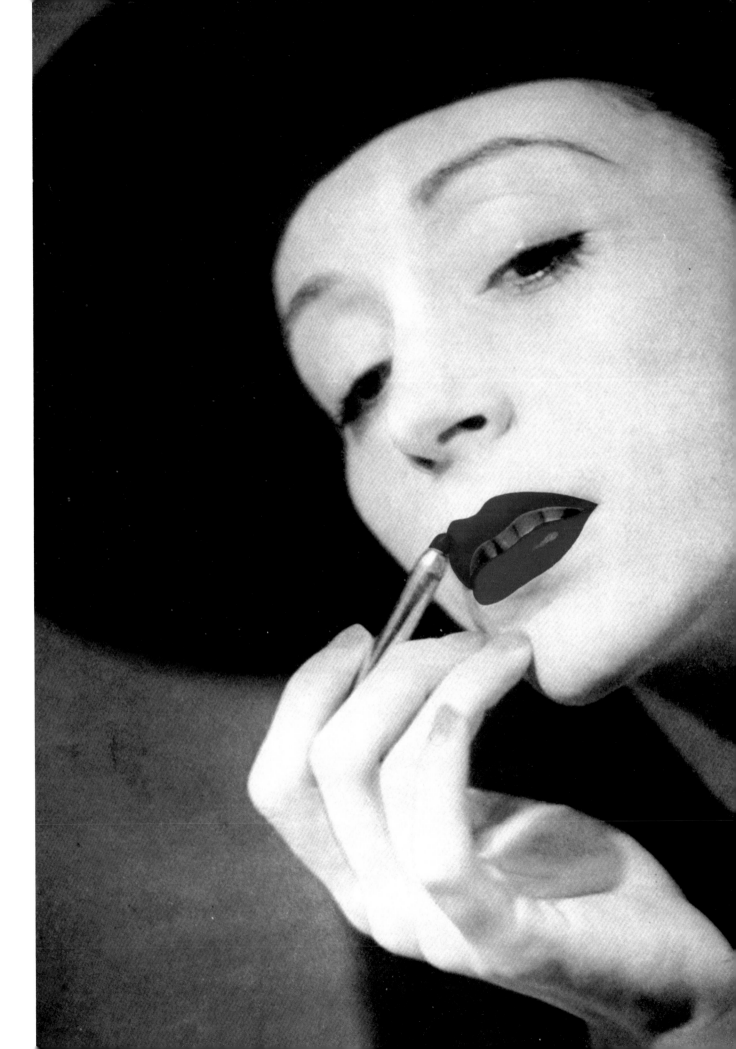

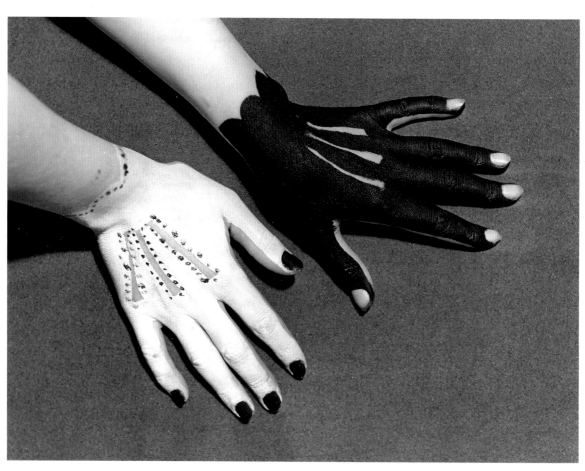

Hands painted by Picasso, c. 1935
Modern gelatin silver print
Collection Juliet Man Ray, Paris

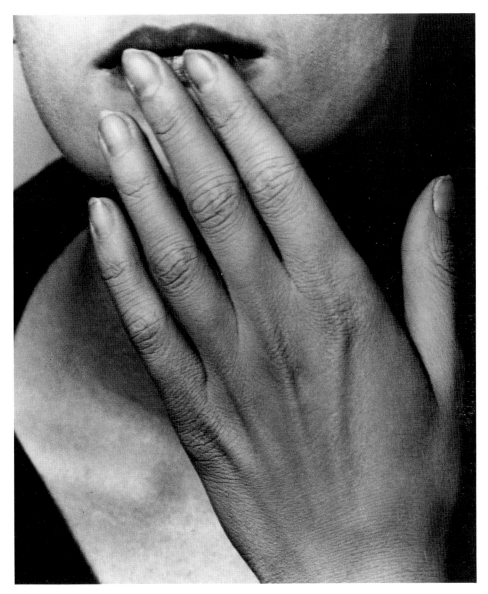

Untitled, 1931
Modern gelatin silver print
Collection Lucien Treillard, Paris

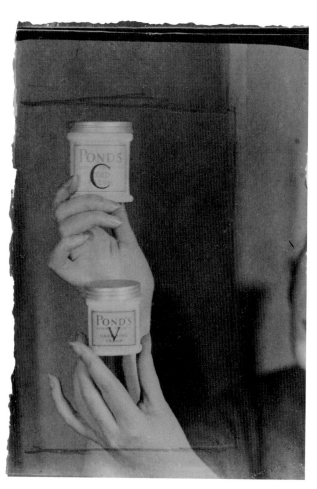

Untitled, c. 1925
Vintage gelatin silver print
Collection Juliet Man Ray, Paris

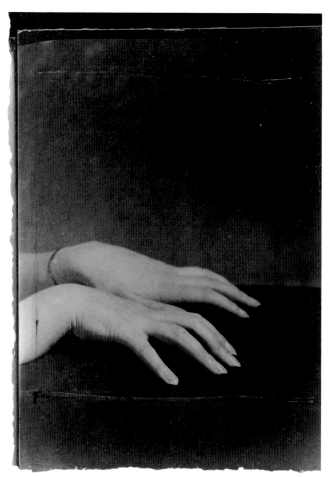

Untitled, c. 1925
Vintage gelatin silver print
Collection Juliet Man Ray, Paris

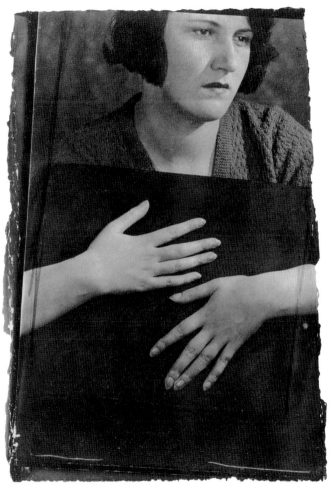

Untitled, c. 1925
Vintage gelatin silver print
Collection Juliet Man Ray, Paris

Man Ray, who has been painting in Hollywood, momentarily returns to his former medium, photography, with this extraordinary study of a woman's face for the beauty issue.
BAZAAR, November 1942
Photomechanical reproduction
Collection Juliet Man Ray, Paris

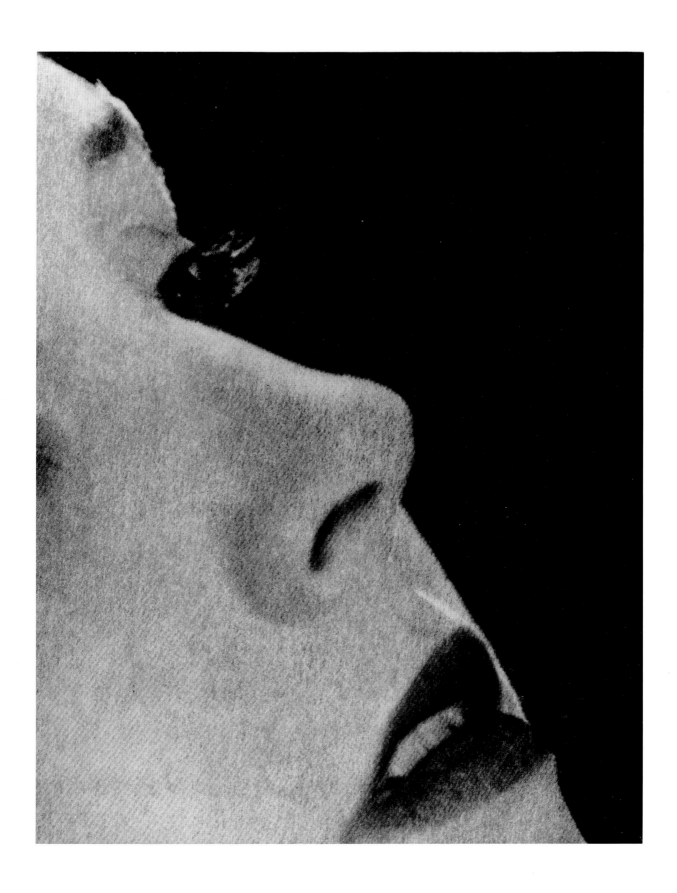

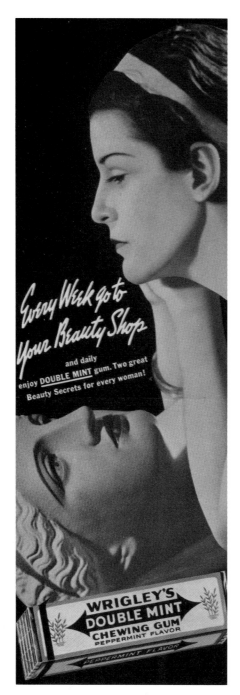

Advertisement for Wrigley's, c. 1935
Photomechanical reproduction
Collection Juliet Man Ray, Paris

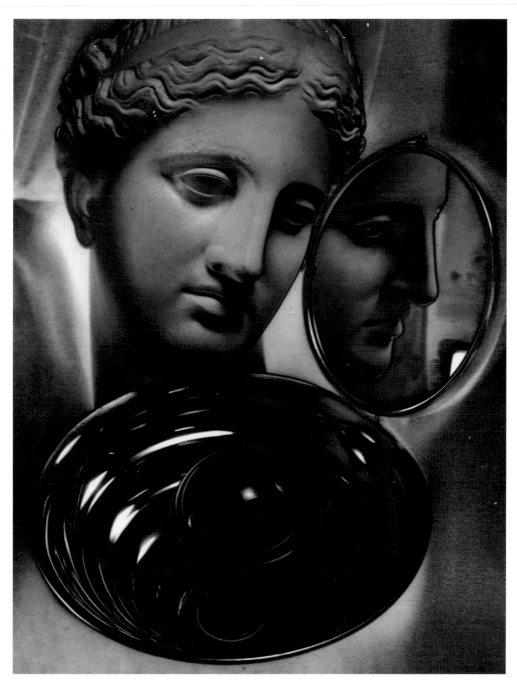

Untitled, 1932
Modern gelatin silver print
Collection Lucien Treillard, Paris

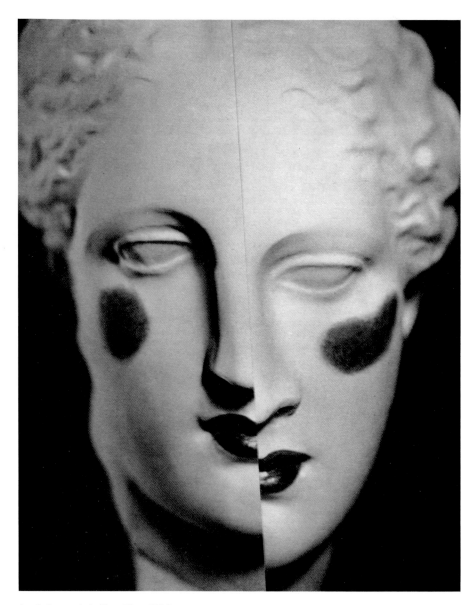

La Science de la Beauté, c. 1932
(The Science of Beauty)
Femina, November 1932
Photomechanical reproduction
Collection International Center of Photography, New York

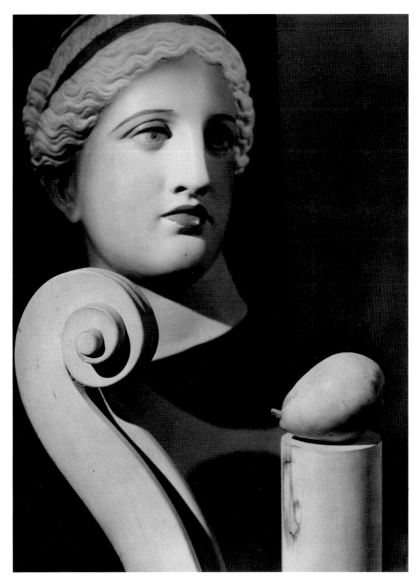

En pleine 'occultation' de Vénus, 1934
(The Full Concealment of Venus)
Modern gelatin silver print
Collection Lucien Treillard, Paris

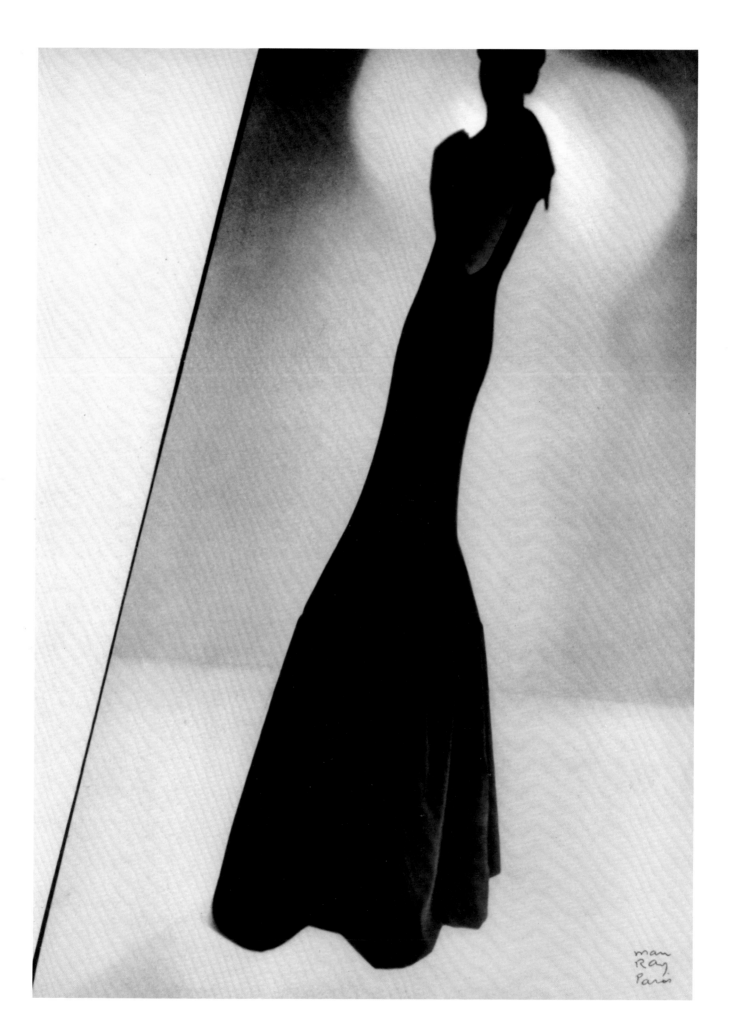

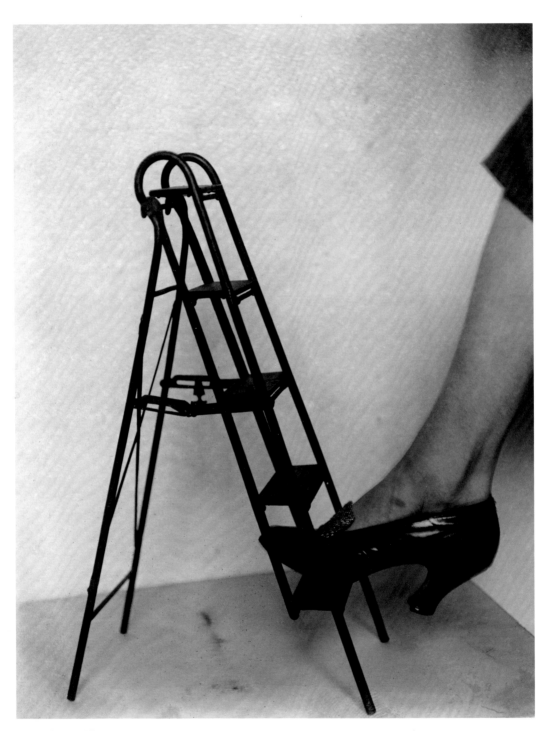

Untitled, c. 1925
Modern gelatin silver print
Collection Juliet Man Ray, Paris

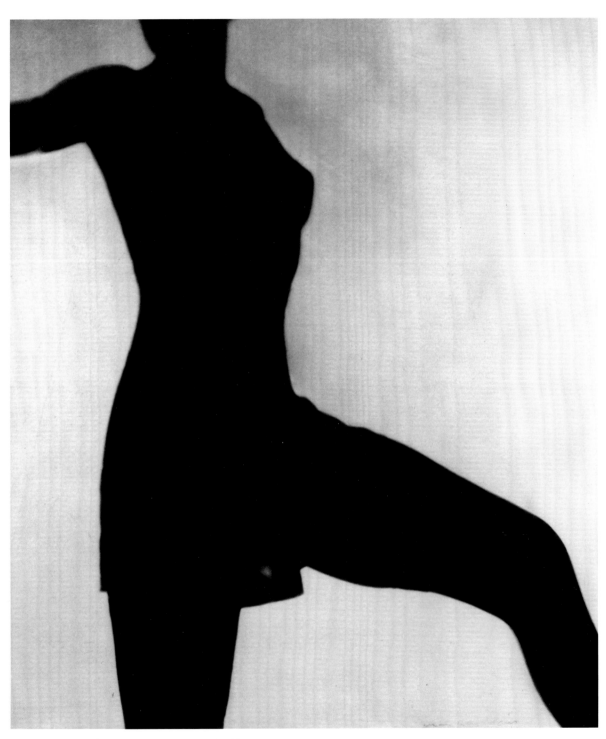

The line we strive for - a smooth curve over the hips.
BAZAAR, September 1935
Photomechanical reproduction
Collection Juliet Man Ray, Paris

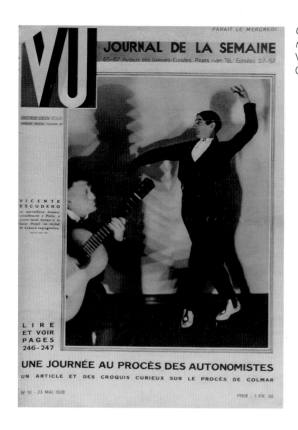

Corner of Studio,
rue Campagne Première, 1926
Vintage gelatin silver print
Collection Juliet Man Ray, Paris

Vu, 23 May, 1928
Photomechanical reproduction
Collection International Center of
Photography Library, New York

(right) *Lanvin's classic white chiffon*
dress with stitched lamé around the
neck and a curious belt made of petals
of the same material.
BAZAAR, November 1935
Photomechanical reproduction
Collection Juliet Man Ray, Paris

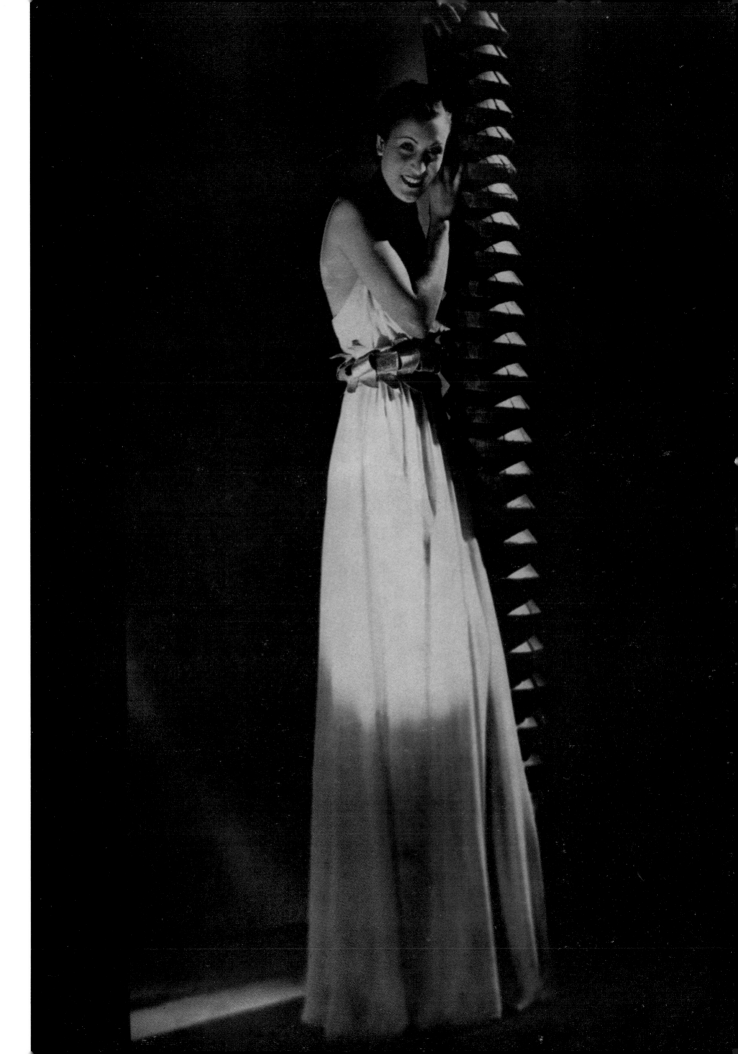

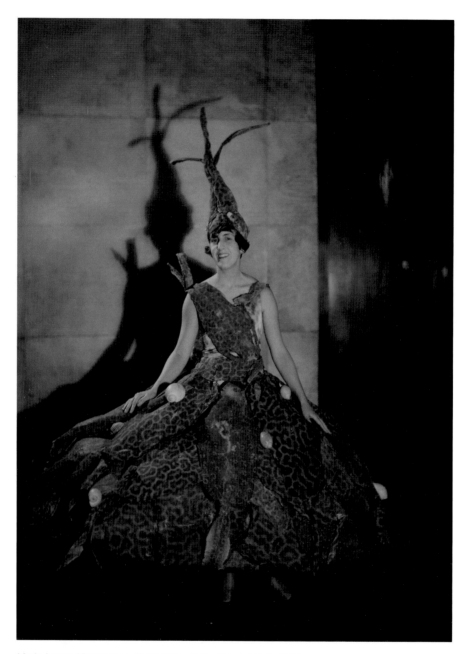

Marie-Laure, Vicomtesse de Noailles, at the Futurist Ball, 1927
A descendant of the Marquis de Sade and prominent patron
of the Parisian avant-garde.
Vintage gelatin silver print
Collection Lucien Treillard, Paris

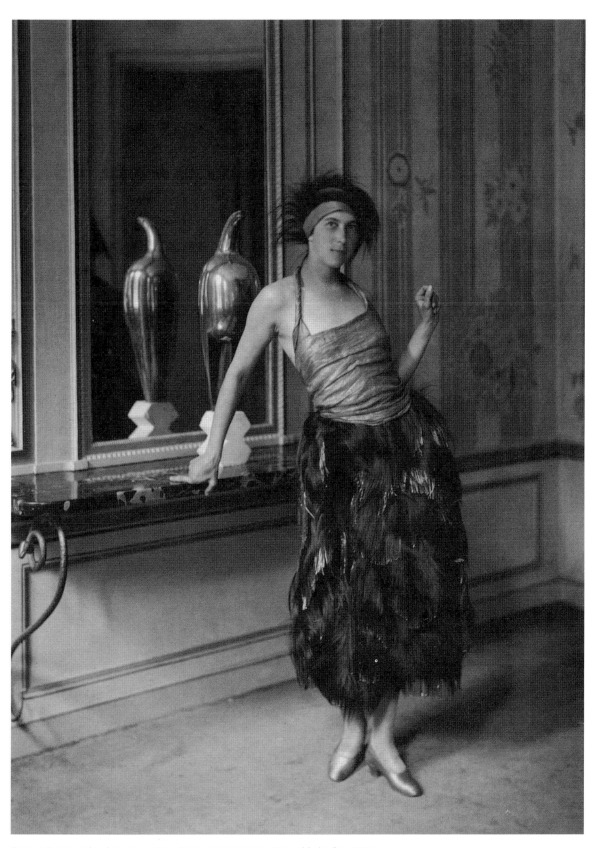

Denise Poiret, wife of designer Paul Poiret, posed in his dress "Mythe," c. 1922
Brancusi sculpture "Maiastra," acquired by the designer in 1912, is in the background.
Modern gelatin silver print from copy negative
Courtesy Musée de la Mode et du Costume, Palais Galliéra, Paris

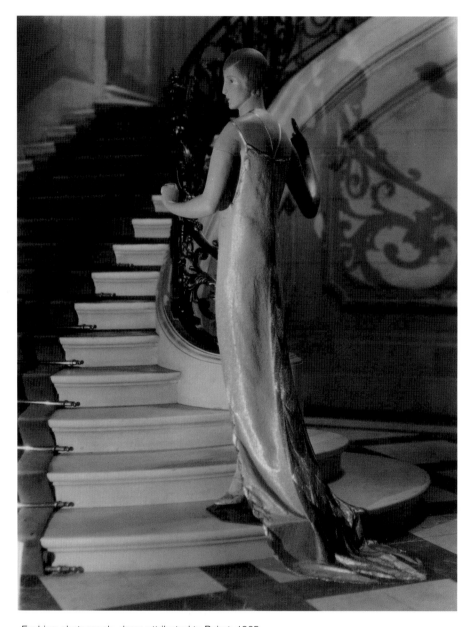

Fashion photograph, dress attributed to Poiret, 1925
Taken at the Pavillon de l'Elégance in the Grand Palais,
part of the International Exposition des Arts Décoratifs
et Industriels Modernes, Paris.
Modern gelatin silver print
Published on the cover of *La Révolution surréaliste*, 15 July, 1925
Collection Lucien Treillard, Paris

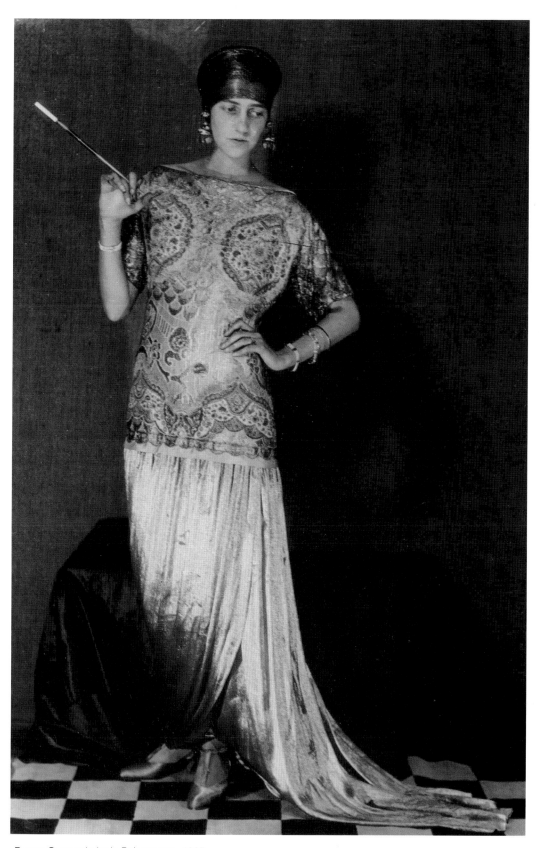

Peggy Guggenheim in Poiret gown, 1925
Modern gelatin silver print
Published in *Bonniers Veckotidning*, 1925
Collection Juliet Man Ray, Paris

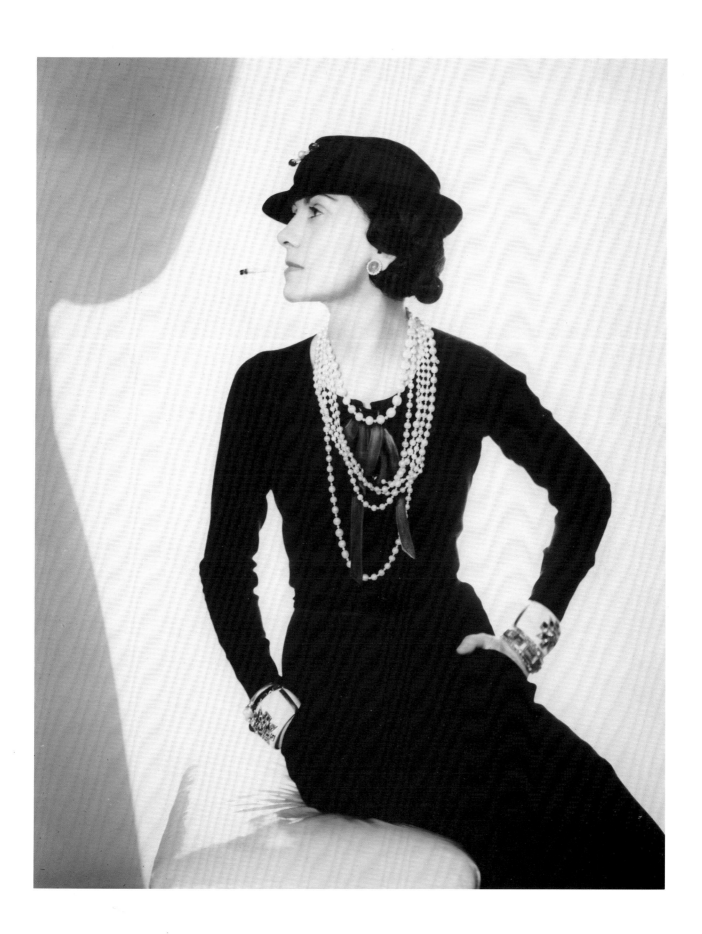

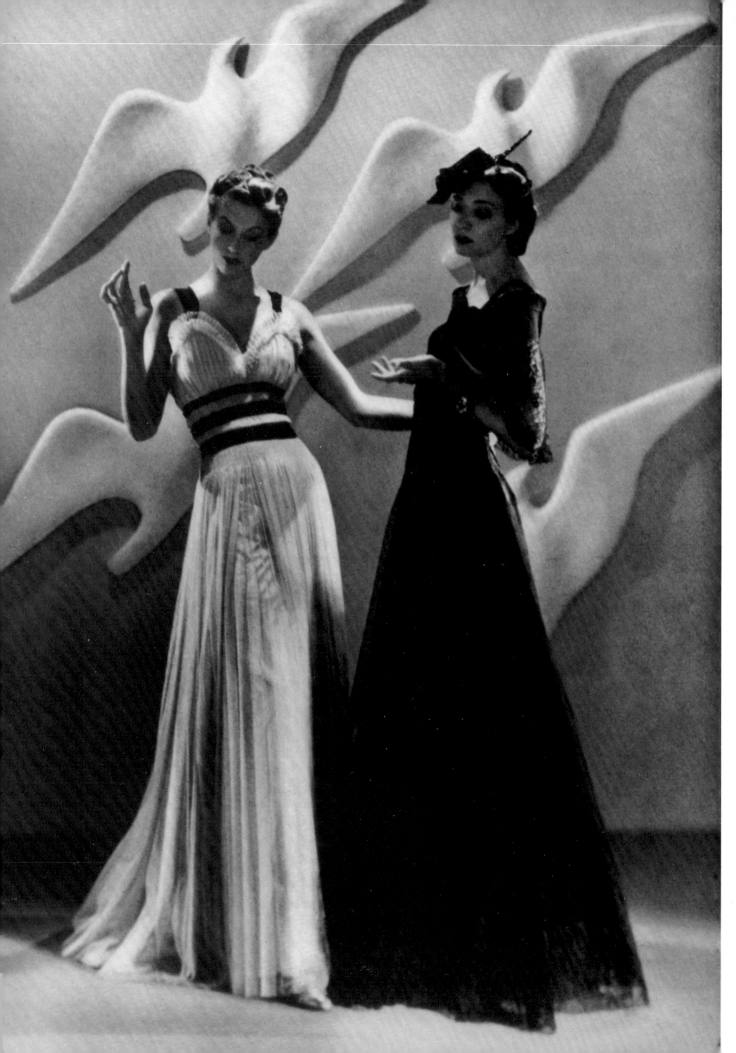

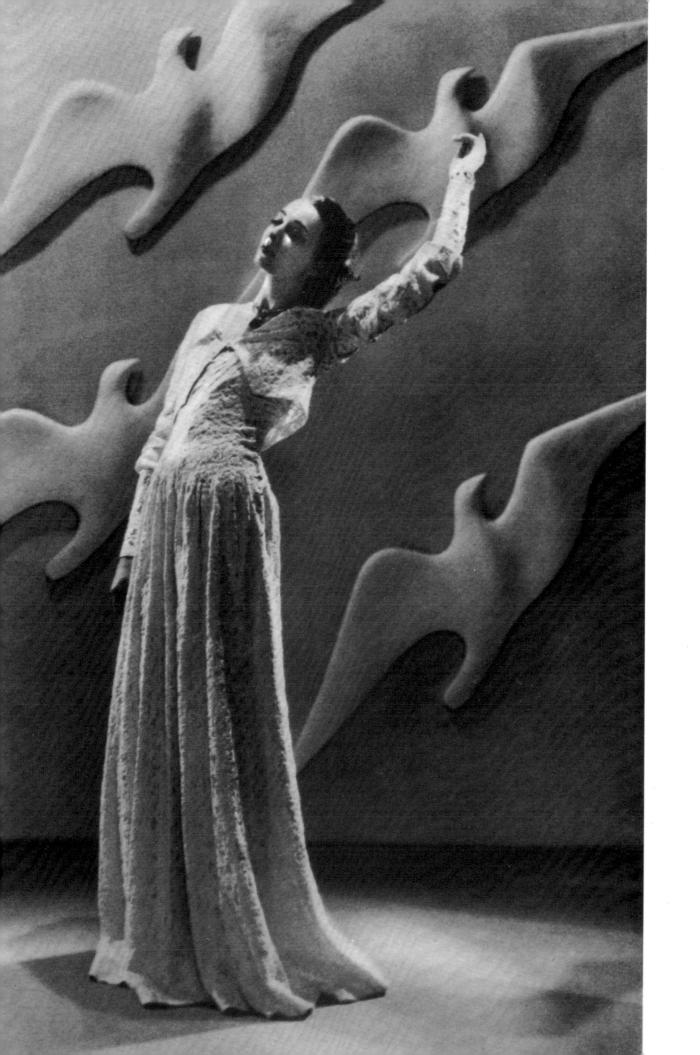

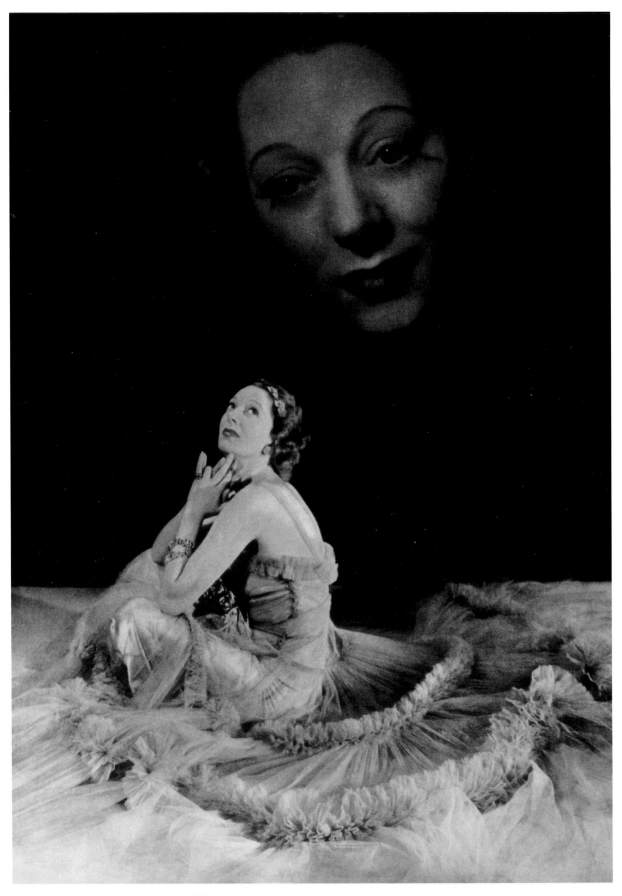

Noël Coward's magnificent obsession: Miss Gertrude Lawrence.
Norman Hartnell made the dress for Miss Lawrence's "Shadow Play" *dance number.*
BAZAAR, December 1936
Photomechanical reproduction from multiple print
Collection Juliet Man Ray, Paris

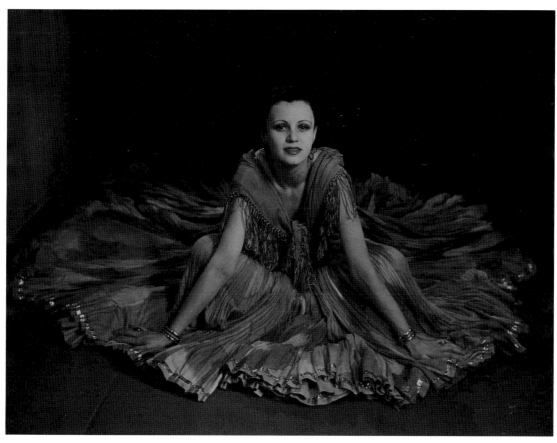

Danses-Horizons, 1934
Vintage gelatin silver print
Published in *Minotaure*, Number 5, 1934-35
Collection Lucien Treillard, Paris

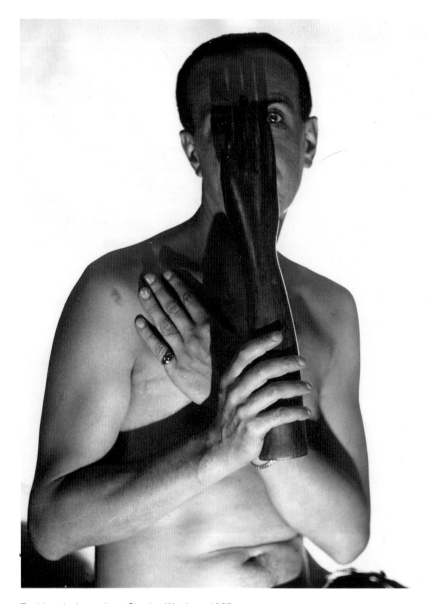

Fashion designer Jean-Charles Worth, c. 1925
Modern gelatin silver print
Collection Juliet Man Ray, Paris

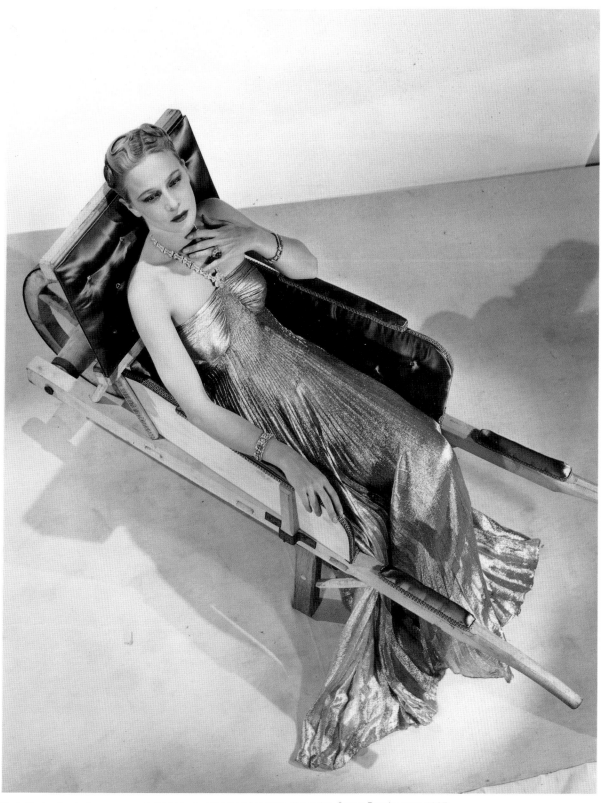

Model in Lucien Lelong gown, seated in wheelbarrow by surrealist artist, Oscar Dominguez, 1937
Modern gelatin silver print
Published in *Minotaure*, 3, Number 10, 1937
Collection Lucien Treillard, Paris

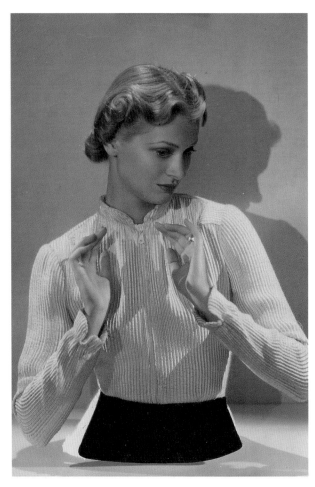

Legless fashion model, c. 1940
Vintage gelatin silver print
Collection Lucien Treillard, Paris

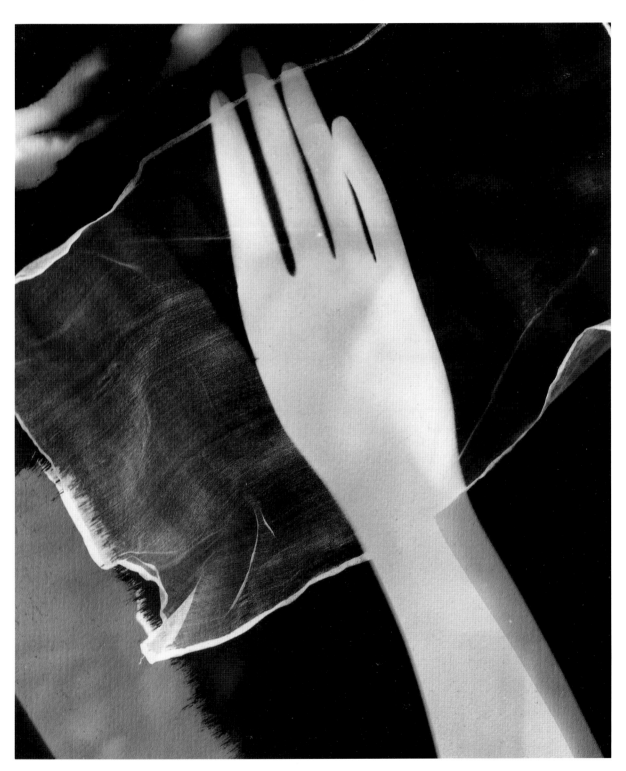

Rayograph, 1927
Modern gelatin silver print
Collection Lucien Treillard, Paris

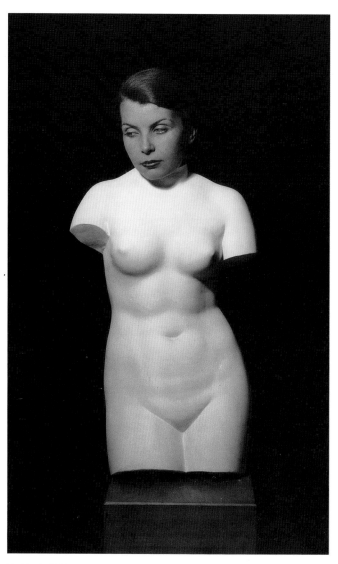

Untitled, 1933
Modern gelatin silver print
Variant published in *Paris Magazine*, September 1934
Collection Lucien Treillard, Paris

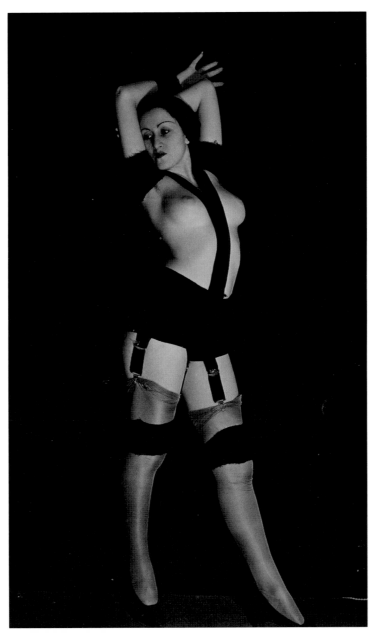

Untitled, c. 1928-29
Commissioned by William Seabrook.
Vintage gelatin silver print
Collection Juliet Man Ray, Paris

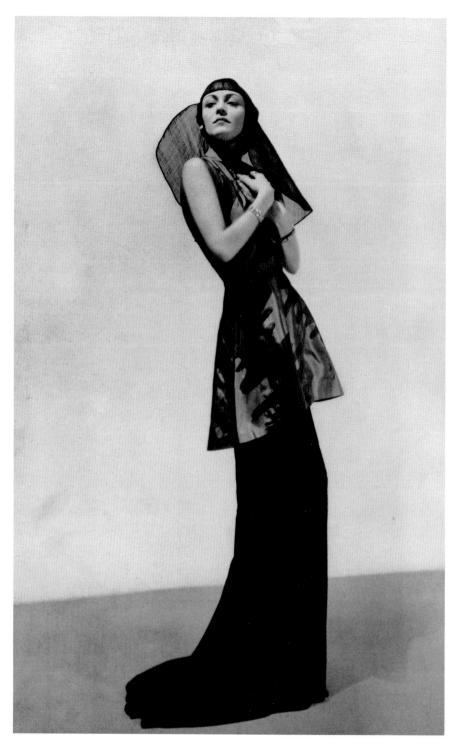

Serpent of the Nile – Alix's headdress in fibre net, with a silk jersey skirt and taffeta tunic.
BAZAAR, April 1936
Photomechanical reproduction
Collection Juliet Man Ray, Paris

Fashions by Radio.
Graphic design by art director Alexey Brodovitch.
BAZAAR, September 1934
Photomechanical reproduction
Collection Juliet Man Ray, Paris

ALL COLLECTIONS VIOLENTLY PICTURESQUE
LOOK 1880 ONE MINUTE, 1950 THE NEXT
THE MOST FANTASTIC MODERN MATERIALS
STIFF AS INFANTAS IN THE EVENING
EVERYONE IS CUTTING WHOOPSY BANGS
DO NOT BELIEVE THAT DERRIERES ARE FLAT
CROWNS ZOOM HIGH AS HUSSARS
WONDERFUL NEW SHADE OF VIOLET BLUE

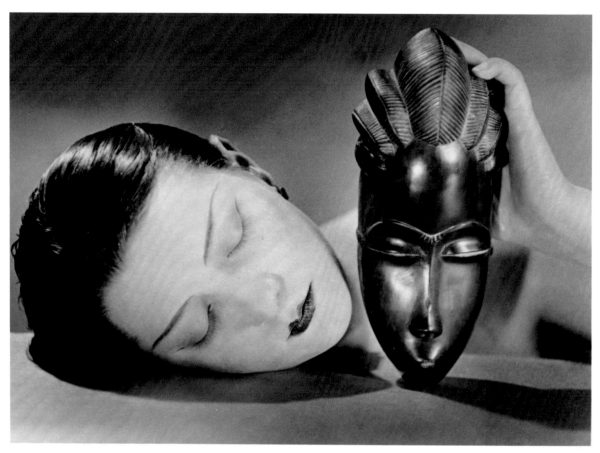

Noire et blanche, 1926
(Black and White)
Modern gelatin silver print
Published in French *Vogue*, May 1926
and *Variétés*, 15 July, 1928
Collection Lucien Treillard, Paris

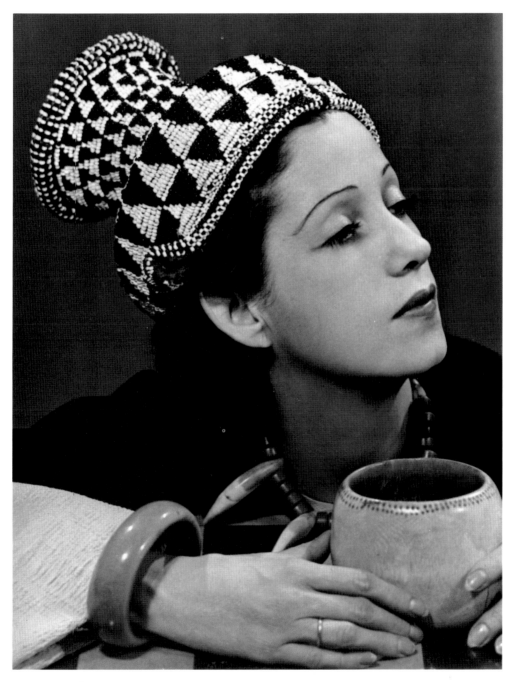

La mode au Congo, 1937
(Congo Fashion)
Vintage gelatin silver print
Published in *BAZAAR*, September 1937
Collection Juliet Man Ray, Paris

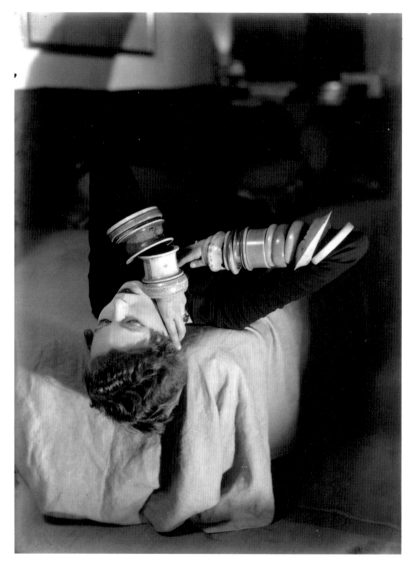

Nancy Cunard, c. 1926
Modern gelatin silver print
Collection Lucien Treillard, Paris

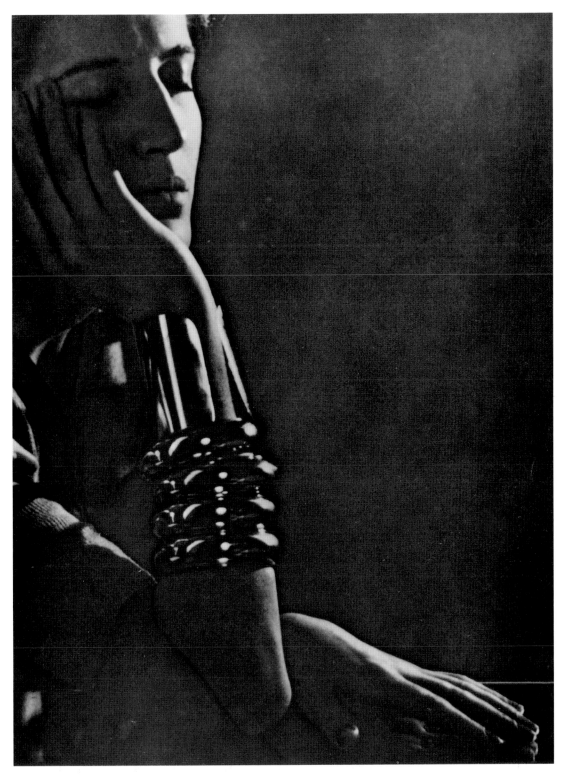

The Bracelets, 1932
Model Jacqueline Goddard
Modern gelatin silver print from solarized negative
Collection Lucien Treillard, Paris

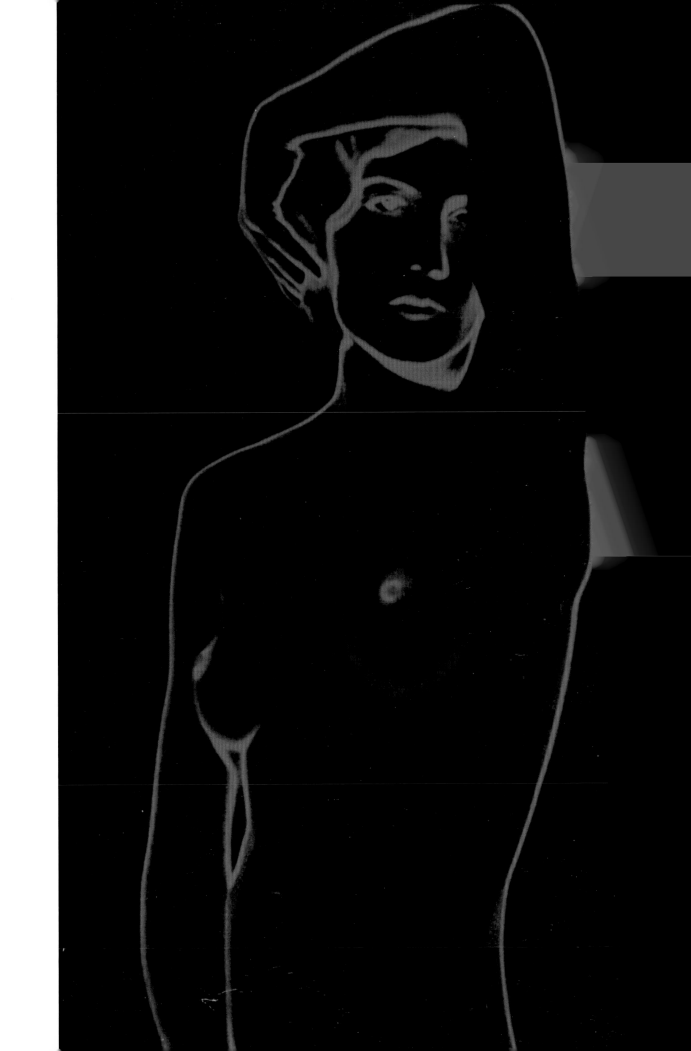

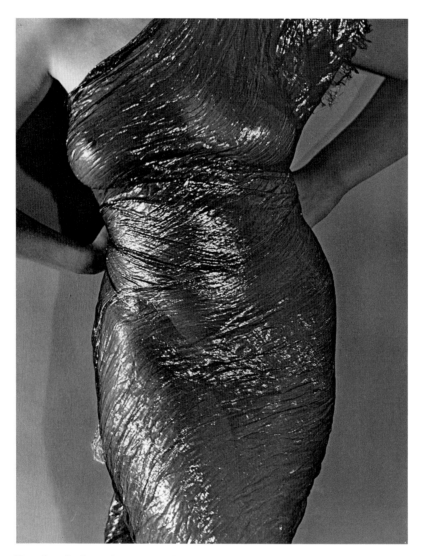

Torso in cellophane dress, c. 1930
Vintage gelatin silver print
Collection Lucien Treillard, Paris

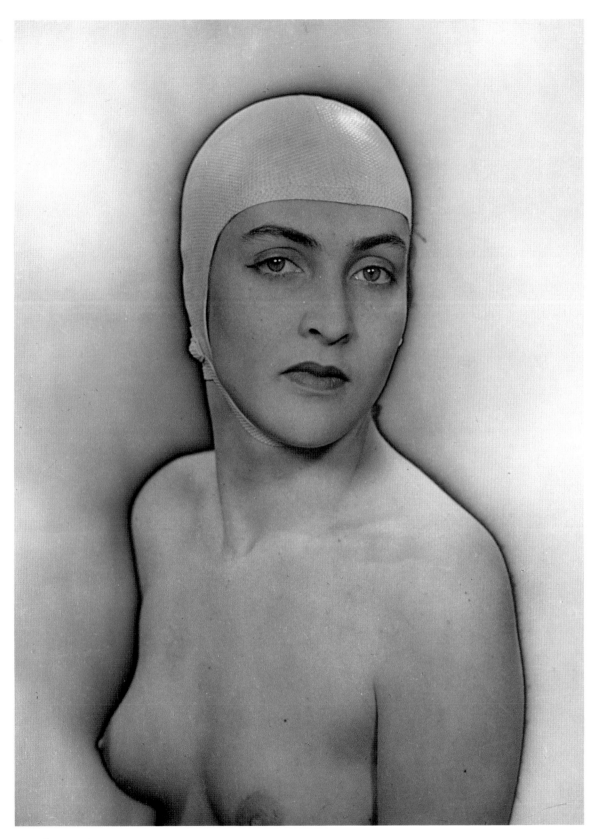

Meret Oppenheim c. 1933
Modern gelatin silver print
Collection Lucien Treillard, Paris

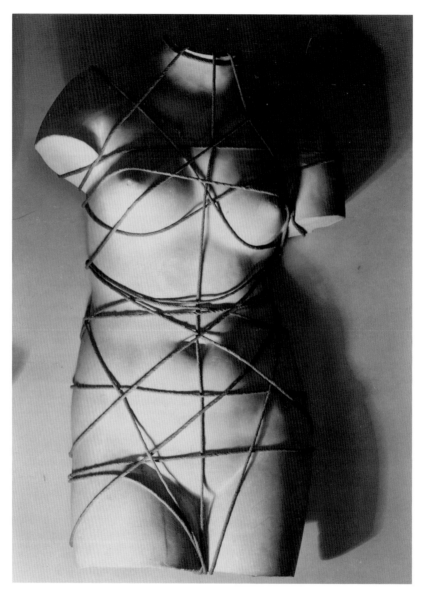

Venus restaurée, 1936
(Venus Restored)
Modern gelatin silver print from copy negative
Private Collection

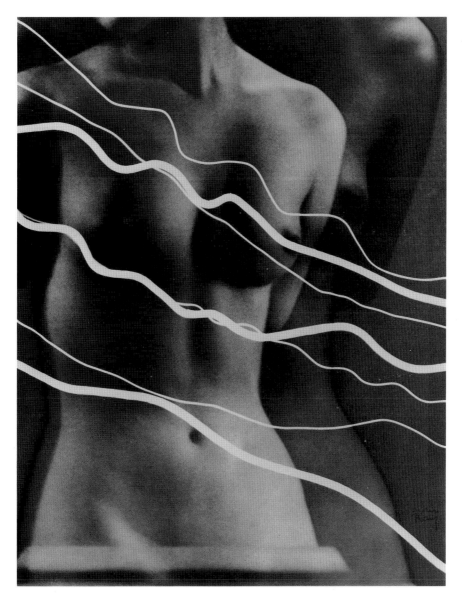

Torso, 1931
From the portfolio *Électricité*.
Photogravure
Collection National Museum of American Art,
Smithsonian Institution, Washington D.C.

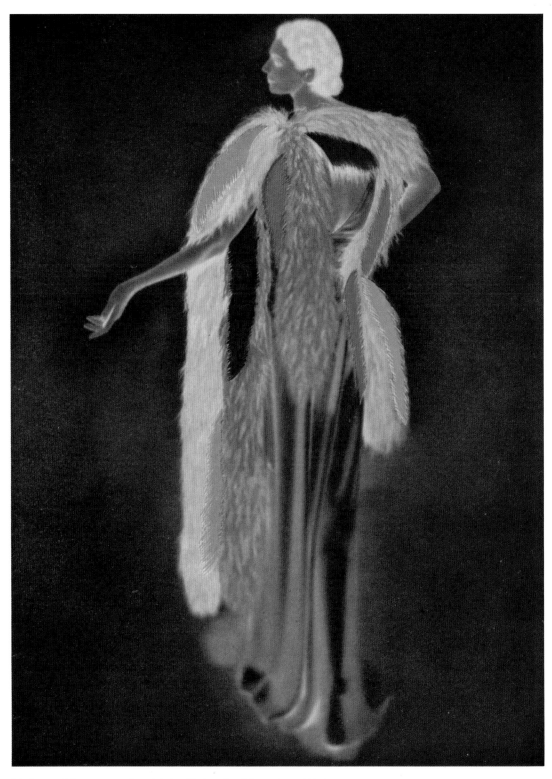

Madness of the moment, Paquin's feather boa in all the colors of Harlem.
BAZAAR, February 1937
Photomechanical reproduction from solarized negative
print with color added during the off-set printing process.
Collection Juliet Man Ray, Paris

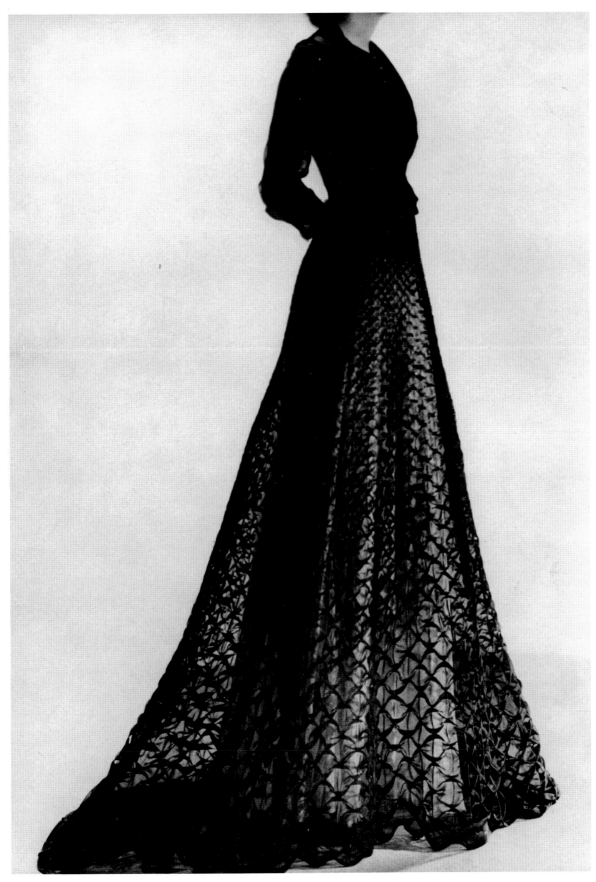

Vionnet's black silk organdie, shirred and cut till it becomes the ornament as well as the fabric.
Modern gelatin silver print from copy negative
Published in *BAZAAR*, July 1936
Private Collection

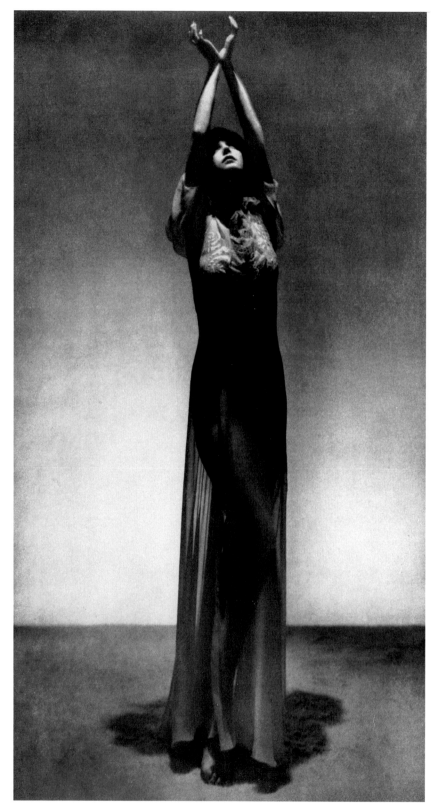

Rise from bed like a mermaid in a sea-shell-pink chiffon night gown.
BAZAAR, July 1937
Photomechanical reproduction
Collection Juliet Man Ray, Paris

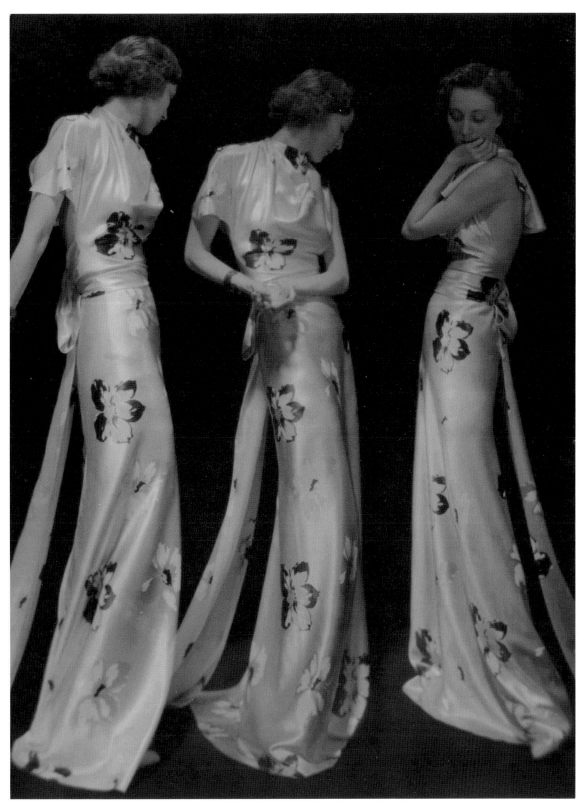

Louiseboulanger – a new cut and a new white crêpe satin
splashed with pansy browns and yellows.
Vintage gelatin silver print
Published in *BAZAAR*, March 1936
Courtesy Keith DeLellis, New York

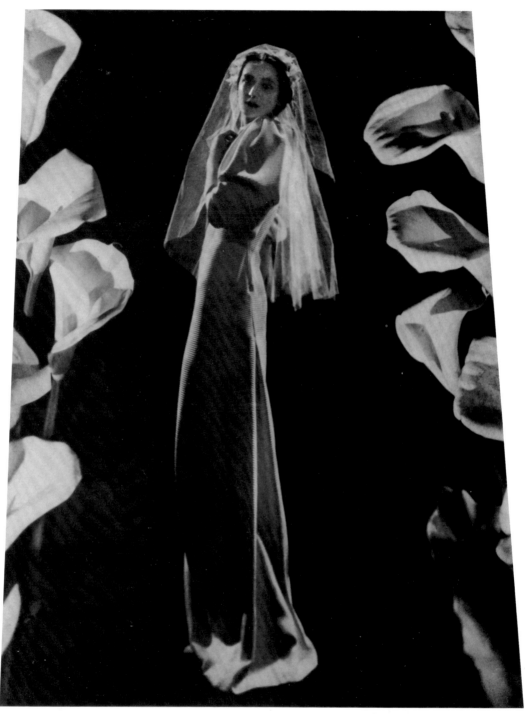

The Bride - Schiaparelli's dress of heavy white ribbed rayon ottoman.
BAZAAR, April 1936
Photomechanical reproduction
Collection Juliet Man Ray, Paris

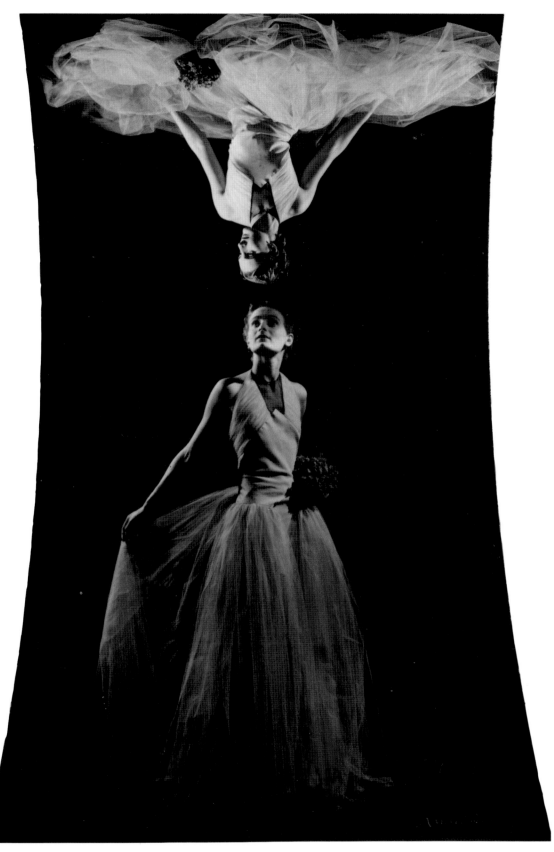

Untitled fashion photograph, 1936
Modern gelatin silver print
Collection Lucien Treillard, Paris

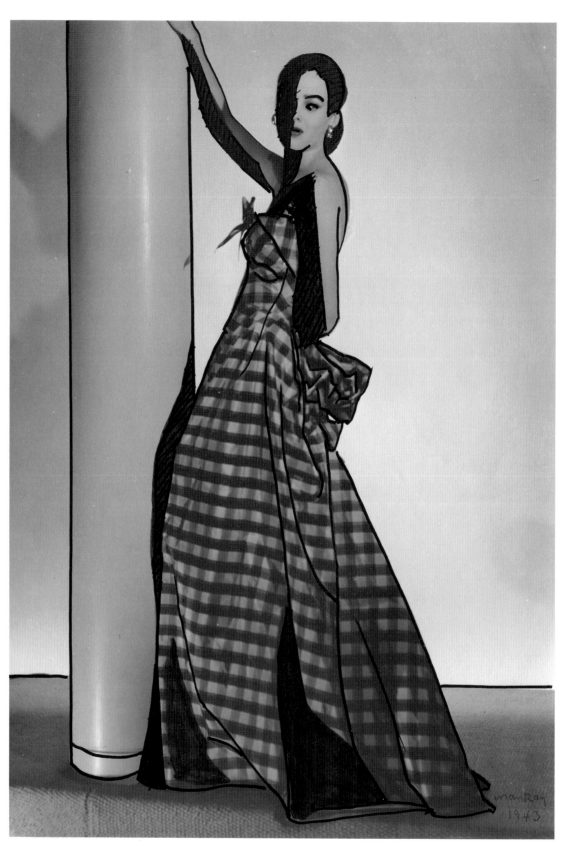

Nattalie, 1943
Vintage gelatin silver print with India ink
Collection Lucien Treillard, Paris

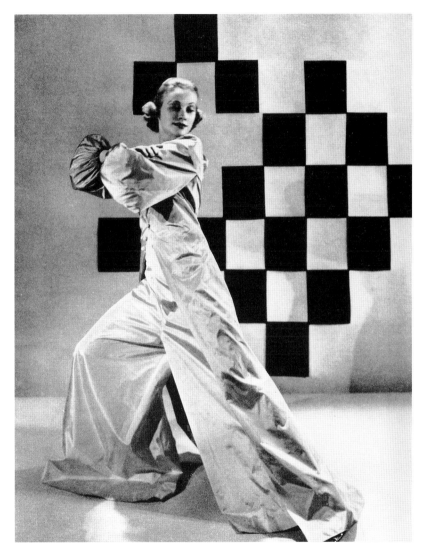

*Schiaparelli's taffeta Pagliacci trousers in yellow
with changeable orchid (colored) coat.*
BAZAAR, January 1937
Photomechanical reproduction
Collection Juliet Man Ray, Paris

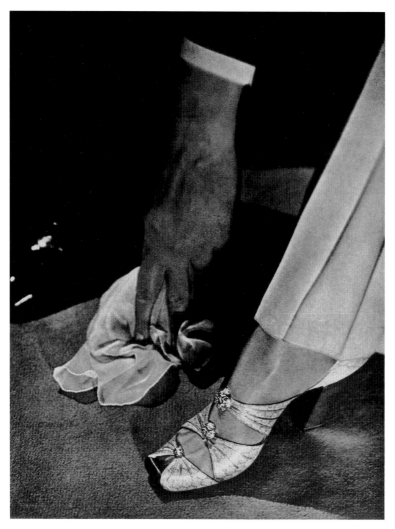

Padova's gold lamé sandal clasped thrice with jewels.
BAZAAR, January 1936
Photomechanical reproduction
Collection International Center of Photography, New York

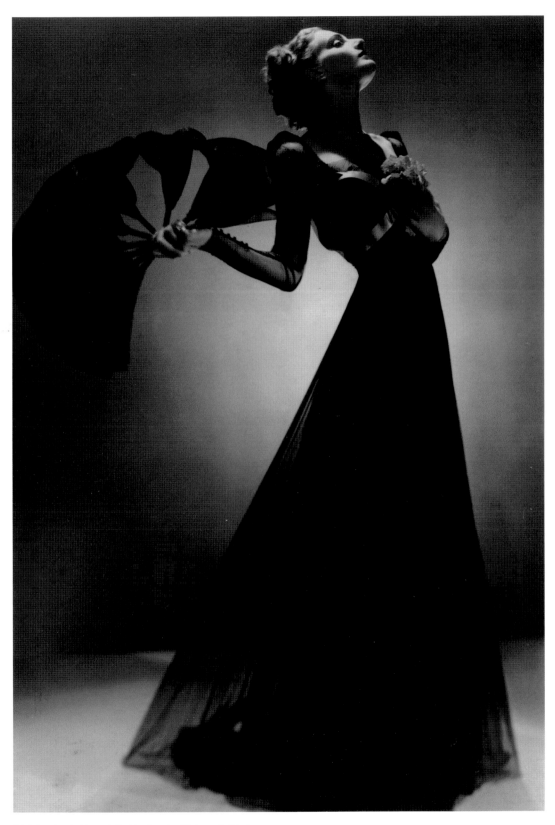

Mainbocher's triumph in black net with long tight sleeves.
Vintage gelatin silver print
Published in *BAZAAR,* March 1936
Courtesy Keith DeLellis, New York

We've all been to palmists and had them read our character in our hands.
Make no mistake, out of the corner of the eye they size up our faces, too.
BAZAAR, October 1941
Photomechanical reproduction
Collection International Center of Photography, New York

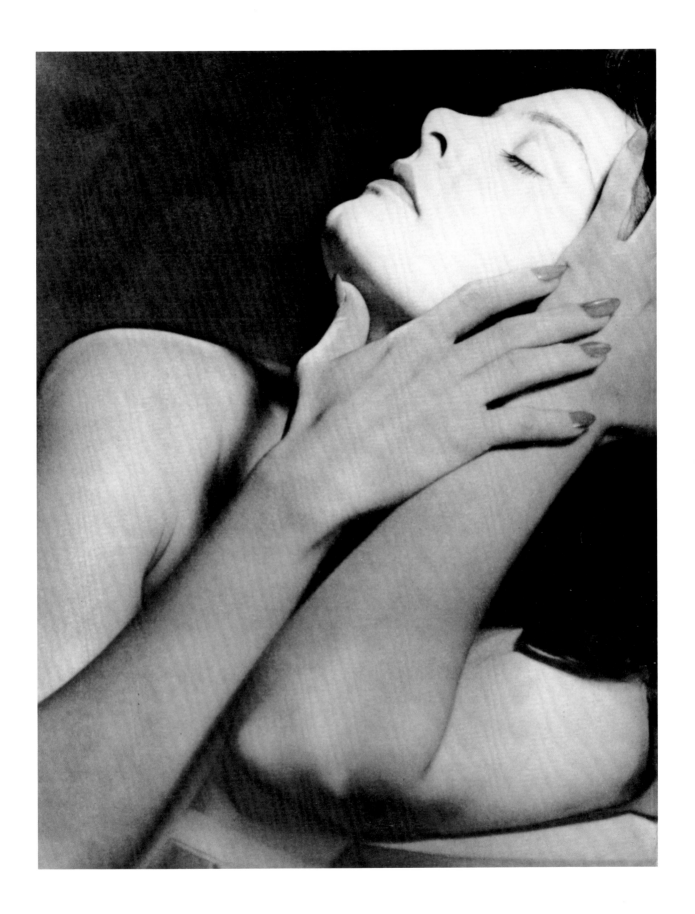

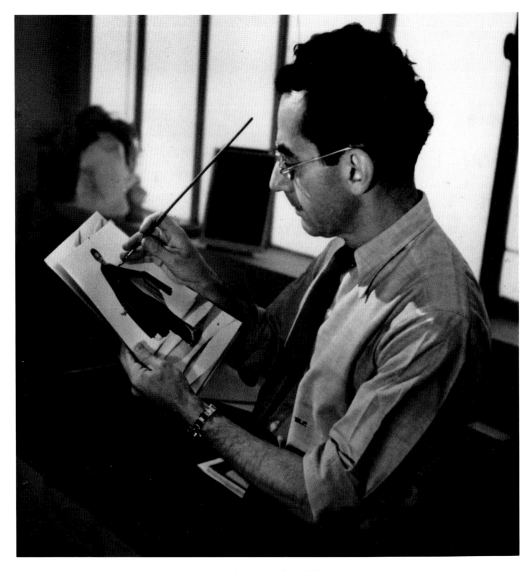

Man Ray retouching a fashion photograph of a dress by Alix, 1937
Photograph by Roger Schall.
Modern gelatin silver print
Published in *LIFE*, 6 September, 1937
Collection Lucien Treillard, Paris

CHRONOLOGY

1890. August 27, born (Emanuel Radnitsky) in Philadelphia, Pennsylvania.

1897. Moves with family to Brooklyn, New York.

1905. Takes name Man Ray. Thereafter known only as Man Ray.

1908-12. Works as a draftsman and graphic designer. Frequents Stieglitz's gallery 291. Studies art at evening classes in various schools including National Academy of Design, New York.

1912-13. Takes drawing classes at the Francisco Ferrer Social Center, New York. Designs covers for Emma Goldman's magazine *Mother Earth*.

1914. Moves to Ridgefield, New Jersey joining others in a small artist's colony. Marries Donna (Adon Lacroix), a Belgian writer, who introduces him to the work of French symbolist writers.

1915. Meets Marcel Duchamp in Ridgefield, New Jersey. Returns to New York. First one-person show of paintings at Daniel Gallery, New York. Begins photography in order to reproduce his paintings for catalogues.

1916-20. Participates in avant-garde activities in New York with Marcel Duchamp and Francis Picabia. Frequents the salon of Walter and Louise Arensberg.

1917. Works on first Aerographs, paintings made with a spray-gun. Second one-person exhibition at Daniel Gallery.

1919. Third one-person exhibition at Daniel Gallery.

1920. With Marcel Duchamp and Katherine Dreier, founds Société Anonyme to promote the understanding of avant-garde art in the United States. Meets Elsa Schiaparelli in New York.

1921. With Marcel Duchamp and Francis Picabia publishes single issue of *New York Dada*. Leaves New York for Paris on July 14. Takes first photographs of the Dada group in November, thus beginning his portrait series of international artists and writers. Through these portraits of the intelligentsia, his reputation is made. December 6, opens one-person exhibition at Librairie Six.

1921-40. Successful as freelance portrait and commercial photographer, filmmaker and painter. Becomes increasingly well known for his fashion photographs and portraits. Publishes frequently in surrealist journals.

1922-29. Lives with Kiki (Alice Prin).

1922. Writes a letter home stating, "I've decided to make portrait photography the source of my livelihood." Gabrielle Picabia introduces Man Ray to Paul Poiret, the couturier, who hires Man Ray to photograph his fashions. Man Ray discovers Rayograph technique while printing Poiret assignment and sells Rayographs to Poiret. Publishes Rayographs as an album, *Les Champs Délicieux*, with a preface by Tristan Tzara. Meets Sylvia Beach, owner of

the bookstore Shakespeare and Company; through this association he photographs many writers, including Ernest Hemingway, Gertrude Stein and James Joyce (Joyce photograph was used to promote his new book *Ulysses*). Man Ray portraits of Picasso and Joyce published for first time in March *Vanity Fair*. Frank Crowninshield, editor of *Vanity Fair*, purchases four Rayographs and features them in the November issue of the magazine. Man Ray photographs the Marquise Casati, with "three sets of eyes," the first of many society commissions.

1923. Produces film, *La Retour à la Raison*, using the cameraless technique of the Rayograph.

1924. Georges Ribemont-Dessaignes publishes Man Ray monograph, Paris. Collaborates with George Hoyningen-Huene on a fashion photography portfolio of "the most beautiful women in Paris." Portfolio sells to a New England department store. André Breton publishes *Manifesto of Surrealism*.

1925. Exhibits in the first surrealist exhibition, Paris. April 25, photographs fashions by Yvonne Davidson, Lanvin and others, in the couture section of the Pavillon de l'Elégance. Image appears on the July 15 cover of *La Révolution surréaliste* and in the August issue of French *Vogue*. Publishes fashion photographs in American *Vogue*.

1926. Produces film *Emak Bakia*.

1928. Produces film *Étoile de Mer*.

1929. Produces film *Les Mystères du Château de Dé*. Parts with Kiki.

1929-32. Meets Lee Miller, she becomes his student, assistant, model, and lover. Together they discover solarization.

1931. Compagnie Parisienne de Distribution d'Électricité, the Paris electric company, commissions, *Électricité*, a portfolio advertisement. Lee Miller is Man Ray's model and assistant on the project.

1932. Participates in surrealist exhibition at the Julien Levy Gallery, New York. Parts with Lee Miller.

1934. Alexey Brodovitch, recently hired by *BAZAAR*'s Editor, Carmel Snow, to serve as Art Director for the magazine, brings Man Ray on as a fashion photographer. Sketches by Christian Bérard are directly transmitted from Paris, via radio, to America. They appear in the September issue of *BAZAAR* with Man Ray's Rayographic impression of a new fashion "coming over the short waves."

1936. Participates in the *International Surrealist Exhibition*, London, and *Fantastic Art, Dada, Surrealism* at the Museum of Modern Art, New York. Numerous fashion assignments for magazines while in New York. *Vanity Fair* ceases publication and becomes part of *Vogue*.

1936-40. Lives with Ady (Adrienne Fidelin).

1937. Collaborates with Paul Éluard on the publication of two books, *Les Mains Libres* and *Facile*. With André Breton publishes, *Photographie n'est pas l'art*.

1940. Leaves Paris during German occupation, thus ending relationship with Ady. Turns down numerous offers in New York to continue fashion photography. Moves to Hollywood, California, in October. Meets Juliet Browner.

1940-52. Lives in Hollywood, where he concentrates on his paintings. Occasionally teaches at the Art Center School, Los Angeles.

1942. Last fashion photography assignment for *BAZAAR*.

1944. Writes script for section of Hans Richter's film, *Dreams that Money Can't Buy*.

1946. Marries Juliet Browner in Beverly Hills in double wedding ceremony with Max Ernst and Dorothea Tanning.

1952. Returns to Paris.

1952-76. Concentrates on painting, working mostly in Paris. Experiments with color photography in late 1950s and early 1960s.

1959. Exhibits at Institute of Contemporary Art, London.

1961. Receives Gold Medal for Photography, Biennale, Venice.

1962. Retrospective Exhibition, Bibliothèque Nationale, Paris.

1966. Recipient of German Photographic Society Cultural Award. Retrospective Exhibition, Los Angeles County Museum of Art.

1971. Retrospective exhibition – originating at Museum Boymans-Van Beuningen, Rotterdam – travels to Musée National d'Art Moderne, Paris, and Louisiana Museum, Humlebaek, Denmark.

1976. Dies, November 18, in Paris.

1982. Exhibition with over 300 photographs, paintings, objects – Centre Georges Pompidou, Paris.

1988. Retrospective exhibition – originated at the National Museum of American Art, Smithsonian Institution, Washington, DC – travels throughout the United States.

1990. First fashion photographic retrospective – organized by the International Center of Photography, New York – travels to Europe and Asia.

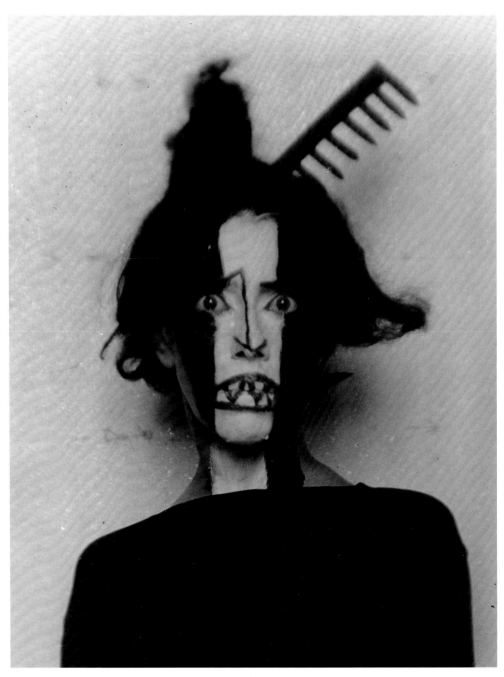

Bronislava Nijinska, sister of Vaslav Nijinski, in
the role of Kikimora in Larionov's ballet, c. 1922
Modern gelatin silver print
Published in *Vanity Fair*, November 1922
Collection Juliet Man Ray, Paris

EXHIBITION CHECKLIST

As Man Ray rarely titled his work, descriptive titles are used in the following checklist. Titles given by the artist, or magazine publishing the image, are listed in italics.

Self-portrait as fashion photographer, c. 1936
Modern gelatin silver print from copy negative, 9 1/8 x 6 13/16"
Private Collection

Denise Poiret, wife of designer Paul Poiret, c. 1922
Modern gelatin silver print from copy negative, 14 x 11"
Courtesy Musée de la Mode et du Costume, Palais Galliéra, Paris

Paul Poiret coatdress with train, c. 1922
Modern gelatin silver print from copy negative, 9 7/16 x 6 13/16"
Private Collection

Janine, a Patou model, c. 1925
Vintage gelatin silver print, 7 13/16 x 5 5/16"
Collection Timothy Baum, New York

Untitled fashion photograph, c. 1925
Vintage gelatin silver print, 8 11/16 x 6 7/16"
Collection Timothy Baum, New York

Untitled fashion photograph, 1926
Modern gelatin silver print, 14 3/16 x 10 1/2"
Collection Lucien Treillard, Paris

A New Method of Realizing the Artistic Possibilities of Photography.
Vanity Fair, November 1922
Photomechanical reproduction, 13 x 9 1/2"
Collection International Center of Photography, New York

Mina Loy, 1918
Modern gelatin silver print, 10 1/4 x 7 3/4"
Collection Lucien Treillard, Paris

***Belle Haleine, Eau de Voilette*, 1921**
Man Ray and Marcel Duchamp's creation for the cover of the one-issue magazine *New York Dada*.
Modern gelatin silver print, 10 1/2 x 8"
Private Collection

***Rrose Sélavy*, 1921**
Modern gelatin silver print, 10 7/8 x 8 5/8"
Collection Lucien Treillard, Paris

Daisy Fellowes, c. 1925
Vintage gelatin silver print, 9 3/8 x 6 7/8"
Collection Lucien Treillard, Paris

Lady Abdy, c. 1925
Vintage gelatin silver print, 9 3/8 x 6 15/16"
Collection Lucien Treillard, Paris

Marie-Laure, Vicomtesse de Noailles, at the Futurist Ball, 1927
Vintage gelatin silver print, 6 1/4 x 4 1/2"
Collection Lucien Treillard, Paris

Tristan Tzara and Nancy Cunard at the Comte de Beaumont Ball, 1924
Modern gelatin silver print from copy negative, 9 3/16 x 6 11/16"
Private Collection

Picasso as toreador at the Comte de Beaumont Ball, 1924
Modern gelatin silver print, 11 3/8 x 8 7/8"
Collection Lucien Treillard, Paris

Bal Blanc, 1930
(White Ball)
Modern gelatin silver print, 5 1/8 x 7"
Published in French *Vogue*, August 1930
Collection Juliet Man Ray, Paris

Nancy Cunard, c. 1926
Modern gelatin silver print, 11 1/4 x 8 3/4"
Collection Lucien Treillard, Paris

Nancy Cunard, c. 1926
Modern gelatin silver print, 6 13/16 x 5 7/8"
Collection Lucien Treillard, Paris

Nancy Cunard, c. 1926
Modern gelatin silver print, 6 13/16 x 5"
Collection Lucien Treillard, Paris

Peggy Guggenheim in Poiret gown, 1925
Modern gelatin silver print, 9 7/16 x 6 1/8"
Published in *Bonniers Veckotidning*, 1925
Collection Juliet Man Ray, Paris

Painter Hélène Perdriat, Paris, c. 1925
Vintage gelatin silver print, 8 3/4 x 6 1/2"
Published in *Charm* Magazine, March 1925
Collection Juliet Man Ray, Paris

***Gertrude Stein at Home*, c. 1922**
Vintage gelatin silver print, 4 3/4 x 3 11/16"
Published in *Vanity Fair*, July 1922
Collection Juliet Man Ray, Paris

Picasso, c. 1922
Modern gelatin silver print, 8 5/8 x 6 5/8"
Published in *Vanity Fair*, July 1922
Collection Lucien Treillard, Paris

Fashion designer Elsa Schiaparelli, c. 1934
Modern gelatin silver print, 15 1/8 x 11 1/8"
Collection Juliet Man Ray, Paris

Fashion designer Elsa Schiaparelli, 1934
Vintage gelatin silver print, 6 1/2 x 3 3/4"
Collection Lucien Treillard, New York

Fashion designer Mainbocher, c. 1935
Vintage gelatin silver print, 9 1/16 x 7"
Collection Juliet Man Ray, Paris

Carmel Snow, Editor of *BAZAAR*, 1938
Vintage gelatin silver print, 9 1/16 x 7"
Collection Juliet Man Ray, Paris

Fashion designer Coco Chanel, c. 1935
Modern gelatin silver print, 11 1/4 x 9"
Collection Lucien Treillard, Paris

Bronislava Nijinska, sister of Vaslav Nijinski,
in the role of Kikimora in Larionov's ballet, c. 1922
Modern gelatin silver print, 12 x 9 3/8"
Published in *Vanity Fair*, November 1922
Collection Juliet Man Ray, Paris

Noire et blanche, 1926
(Black and White)
Modern gelatin silver print, 8 1/8 x 11 3/8"
Published in French *Vogue*, May 1926 and
Variétés, 15 July, 1928
Collection Lucien Treillard, Paris

Fashion designer Jean-Charles Worth, 1925
Modern gelatin silver print, 12 x 9 3/8"
Collection Juliet Man Ray, Paris

Fashion photograph, dress by Lanvin, 1925
Modern gelatin silver print, 11 1/16 x 8 5/8"
Published in French *Vogue*, 21 August, 1925
Collection Lucien Treillard, Paris

Fashion photograph, dress by Yvonne Davidson, 1925
Modern gelatin silver print, 11 3/16 x 8 3/8"
Published in French *Vogue*, 21 August, 1925
Collection Lucien Treillard, Paris

Page layout, French Vogue, 21 August, 1925
Modern gelatin silver print from copy negative, 11 x 14"
Courtesy Musée de la Mode et du Costume,
Palais Galliéra, Paris

Fashion photograph, dress attributed to Poiret, 1925
Modern gelatin silver print, 11 1/4 x 8 5/8"
Published on the cover of *La Révolution surréaliste*,
15 July, 1925
Collection Lucien Treillard, Paris

La Révolution surréaliste, 15 July, 1925
Photomechanical reproduction, 11 7/8 x 7 15/16"
Collection Timothy Baum, New York

Beautiful as the Fortuitous Encounter on a Dissecting
Table of a Sewing Machine and an Umbrella, 1933
Modern gelatin silver print, 9 3/4 x 14 7/8"
Published in *Minotaure*, Nos. 3-4, October-December 1933
Collection Lucien Treillard, Paris

Plaster head with mirror and lamp, 1932
Modern gelatin silver print, 11 5/16 x 8 7/8"
Collection Lucien Treillard, Paris

Plaster head c. 1932
Modern gelatin silver print, 14 7/8 x 9 3/4"
Variant published in *Femina*, November 1932
Collection Lucien Treillard, Paris

La Science de la Beauté, c. 1932
(The Science of Beauty)
Femina, November 1932
Photomechanical reproduction, 13 x 9 1/2"

En pleine 'occultation' de Vénus, 1934
(The Full Concealment of Venus)
Modern gelatin silver print, 11 5/16 x 8 7/16"
Collection Lucien Treillard, Paris

Variant of *En pleine 'occultation' de Vénus*, 1934
Modern gelatin silver print, 8 1/2 x 11"
Collection Lucien Treillard, Paris

Advertisement for Wrigley's, c. 1935
Photomechanical reproduction, 13 x 4 1/2"
Collection Juliet Man Ray, Paris

Nude with plaster torso, c. 1936
Modern gelatin silver print, 10 1/2 x 14 1/8"
Collection Lucien Treillard, Paris

Venus restaurée, 1936
(Venus Restored)
Modern gelatin silver print from copy negative, 6 1/2 x 4 1/2"
Private Collection

Torso, 1931
From the portfolio *Électricité*.
Photogravure, 10 1/4 x 7 15/16"
Collection National Museum of American Art,
Smithsonian Institution, Washington D.C.

Lingerie, 1931
From the portfolio *Électricité*.
Photogravure, 10 1/4 x 8 1/16"
Collection National Museum of American Art,
Smithsonian Institution, Washington D.C.

Torso in cellophane dress, c. 1930
Modern gelatin silver print, 11 1/2 x 9"
Collection Lucien Treillard, Paris

Woman's head on plaster torso, 1933
Modern gelatin silver print, 11 5/8 x 8 1/8"
Variant published in *Paris Magazine*, September 1934
Collection Lucien Treillard, Paris

Lamp with torso, c. 1933
Modern gelatin silver print, 13 11/16 x 10 1/2"
Published in *Photographs by Man Ray, 1920-1934*
Collection Lucien Treillard, Paris

Mannequin by Salvador Dali, 1938
Modern gelatin silver print, 7 5/16 x 5 7/16"
Collection Juliet Man Ray, Paris

Mannequin by Man Ray, 1938
Modern gelatin silver print, 11 x 8 3/16"
Collection Lucien Treillard, Paris

Mannequin by Wolfgang Paalen, 1938
Modern gelatin silver print, 7 1/2 x 5 9/16"
Collection Juliet Man Ray, Paris

Mannequin by André Masson, 1938
Modern gelatin silver print, 7 5/16 x 5 7/16"
Collection Juliet Man Ray, Paris

Legless fashion model, c. 1940
Vintage gelatin silver print, 5 3/8 x 3 9/16"
Collection Juliet Man Ray, Paris

Legless fashion model, c. 1940
Vintage gelatin silver print, 7 x 5"
Collection Juliet Man Ray, Paris

Legless fashion model, c. 1940
Vintage gelatin silver print, 5 3/8 x 3 9/16"
Collection Juliet Man Ray, Paris

Legless fashion model, c. 1940
Vintage gelatin silver print, 5 1/8 x 3 5/8"
Collection Juliet Man Ray, Paris

Legless fashion model, c. 1940
Vintage gelatin silver print, 4 x 5 3/4"
Collection Lucien Treillard, Paris

Legless fashion model, c. 1940
Vintage gelatin silver print, 5 3/8 x 3 5/8"
Collection Juliet Man Ray, Paris

Nattalie, 1943
Vintage gelatin silver print with India ink, 13 3/16 x 9 5/16"
Collection Lucien Treillard, Paris

Model in Lucien Lelong gown, seated in wheelbarrow by
surrealist artist, Oscar Dominguez, 1937
Modern gelatin silver print, 11 1/4 x 8 7/8"
Published in *Minotaure*, 3, Number 10, 1937
Collection Lucien Treillard, Paris

Man Ray's studio, rue Denfert-Rochereau, 1939
Vintage gelatin silver print, 11 5/8 x 8 15/16"
Collection Juliet Man Ray, Paris

Corner of Studio, rue Campagne Première, 1926
Vintage gelatin silver print, 9 x 6 9/16"
Collection Juliet Man Ray, Paris

Sinclair Lewis, author, c. 1926
Modern gelatin silver print, 9 1/8 x 7"
Collection Juliet Man Ray, Paris

Vicente Escudero, flamenco dancer, 1928
Vintage gelatin silver print, 6 3/8 x 4 5/16"
Published on the cover of *Vu*, 23 May, 1928
Collection Juliet Man Ray, Paris

Vu, 23 May, 1928
Photomechanical reproduction, 15 x 10 7/8"
Collection International Center of Photography Library, New York

Lanvin's classic white chiffon dress with stitched lamé
around the neck and a curious belt made of petals
of the same material.
BAZAAR, November 1935
Photomechanical reproduction, 13 x 9 3/8"
Collection Juliet Man Ray, Paris

Cover Page, Man Ray's personal collection of tear
sheets from Harper's BAZAAR, c. 1942
Ink on paper, 18 x 12"
Collection Juliet Man Ray, Paris

Fashions by Radio.
BAZAAR, September 1934
Photomechanical reproduction, 13 x 9 5/16"
Collection Juliet Man Ray, Paris

Nusch Éluard with mirror.
BAZAAR, March 1935
Photomechanical reproduction, 5 7/8 x 4 1/16"
Collection Juliet Man Ray, Paris

Augustabernard's new line. The gown billows at the bottom.
BAZAAR, October 1934
Photomechanical reproduction, 13 x 18"
Collection New York Society Library, New York

Man Ray retouching a fashion photograph of a
dress by Alix, 1937
Photograph by Roger Schall.
Modern gelatin silver print, 9 11/16 x 9 1/4"
Published in *LIFE*, 6 September, 1937
Collection Lucien Treillard, Paris

Man Ray with model, 1937
Photograph by Roger Schall.
Modern gelatin silver print, 9 11/16 x 9 1/8"
Collection Lucien Treillard, Paris

L: Lelong's rampage of colour; Brown velvet skirt,
red sash, green top, yellow bolero.
BAZAAR, February 1938
Photomechanical reproduction, 10 7/16 x 7 3/8"
Collection Juliet Man Ray, Paris

M stands for Mainbocher and for evening dresses
that are starkly tailored.
BAZAAR, January 1938
Photomechanical reproduction, 10 3/4 x 7 3/16"
Collection Juliet Man Ray, Paris

The Pulse of Fashion: Miss June Presser
of the Ziegfeld Follies.
BAZAAR, January 1937
Photomechanical reproduction, 5 11/16 x 3 11/16"
Collection International Center of Photography, New York

Larmes, c. 1930
(Glass Tears)
Modern gelatin silver print, 8 11/16 x 11 3/4"
Collection Lucien Treillard, Paris

Lips of Lee Miller, c. 1930
Modern gelatin silver print, 8 1/2 x 11 3/16"
Collection Lucien Treillard, Paris

Portrait of Lee Miller, 1930
Modern gelatin silver print from solarized negative,
11 11/16 x 9 1/4"
Collection Lucien Treillard, Paris

Fashion photograph of Lee Miller, 1931
Vintage gelatin silver print, 7 1/4 x 4 1/2"
Collection Lee Miller Archives, England

Plaster cast in front of L'Heure de l'observetoire,
Les amoureux, 1934
(Observatory Time - The Lovers)
Vintage gelatin silver print, 5 7/8 x 8 3/8"
Collection Juliet Man Ray, Paris

Nude in front of L'Heure de l'observetoire,
Les amoureux, 1934
Modern gelatin silver print, 3 5/16 x 4 3/8"
Collection Juliet Man Ray, Paris

Against his surrealist painting - L'Heure de l'observetoire,
Les amoureux - *Man Ray photographs a beach coat by*
Heim of white silk painted with little brown foxes.
Modern gelatin silver print from copy negative, 14 x 11"
Published in *BAZAAR*, November 1936
Private Collection

The Red Badge of Courage.
BAZAAR, November 1937
Photomechanical reproduction with color added
during the off-set printing process, 13 x 18 5/8"
Collection International Center of Photography, New York

Nude, c. 1929
Modern gelatin silver print from solarized negative, 11 x 8 3/16"
Variant published in *BAZAAR*, October 1940
Collection Lucien Treillard, Paris

Beauty in Ultra-Violet.
BAZAAR, October 1940
Photomechanical reproduction from solarized negative print
with color added during the offset process, 13 x 9 $^3/_8$"
Collection Juliet Man Ray, Paris

Calla Lilies, c. 1930
Modern gelatin silver print from solarized negative, 11 $^1/_4$ x 8 $^{15}/_{16}$"
Collection Lucien Treillard, Paris

*We've all been to palmists and had them read our character
in our hands. Make no mistake, out of the corner of the eye
they size up our faces, too.*
BAZAAR, October 1941
Photomechanical reproduction, 11 $^{13}/_{16}$ x 9 $^7/_{16}$"
Collection International Center of Photography, New York

Untitled, c. 1931
Modern gelatin silver print from solarized negative, 8 $^1/_2$ x 11 $^3/_{16}$"
Collection Lucien Treillard, Paris

Alberto Giacometti, sculptor, c. 1934
Modern gelatin silver print from solarized negative, 11 x 8 $^3/_{16}$"
Collection Lucien Treillard, Paris

*The bolero appears again and again all throughout
the Chanel collection.*
BAZAAR, September 1937
Photomechanical reproduction, 10 $^{15}/_{16}$ x 7 $^1/_2$"
Collection Juliet Man Ray, Paris

*Chanel accents the bandaged waist with
spreading skirts of tulle.*
BAZAAR, September 1937
Photomechanical reproduction, 10 $^7/_8$ x 7 $^{13}/_{16}$"
Collection Juliet Man Ray, Paris

**Adrienne Fidelin with Giacometti sculpture,
"Albatross," c. 1935**
Vintage gelatin silver print, 3 $^5/_{16}$ x 2 $^5/_{16}$"
Collection Juliet Man Ray, Paris

**Adrienne Fidelin with Giacometti sculpture,
"Albatross," c. 1935**
Vintage gelatin silver print, 3 $^1/_4$ x 2 $^1/_4$"
Collection Juliet Man Ray, Paris

**Adrienne Fidelin with Giacometti sculpture,
"Albatross," c. 1935**
Vintage gelatin silver print, 3 $^1/_4$ x 2 $^5/_{16}$"
Collection Juliet Man Ray, Paris

*Day begins - in a pale orange nightgown that Gorbatowsky
slits to the waist in back.*
BAZAAR, January 1936
Photomechanical reproduction, 13 $^1/_{16}$ x 9 $^9/_{16}$"
Collection International Center of Photography, New York

Meret Oppenheim c. 1933
Modern gelatin silver print, 11 $^1/_4$ x 8 $^7/_8$"
Collection Lucien Treillard, Paris

Meret Oppenheim, c. 1935
Modern gelatin silver print, 14 $^7/_8$ x 8 $^1/_4$"
Collection Lucien Treillard, Paris

Meret Oppenheim, c. 1935
Modern gelatin silver print, 14 $^7/_8$ x 9 $^1/_4$"
Collection Lucien Treillard, Paris

Nusch Éluard, c. 1930
Carte-postale, 5 $^1/_4$ x 3 $^1/_2$"
Collection Juliet Man Ray, Paris

**Nusch Éluard, Paul Éluard, Man Ray,
and Adrienne Fidelin, 1936**
Carte-postale, 5 $^3/_8$ x 3 $^3/_{16}$"
Collection Juliet Man Ray, Paris

Nusch Éluard and Adrienne Fidelin, c. 1936
Modern gelatin silver print, 11 $^7/_{16}$ x 8 $^7/_8$"
Collection Lucien Treillard, Paris

Facile, 1935
By Paul Éluard and Man Ray.
Photomechanical reproduction, 9 $^3/_4$ x 7 $^1/_8$"
Collection Timothy Baum, New York

Nude from *Facile*, 1936
Modern gelatin silver print, 11 $^1/_8$ x 8 $^5/_8$"
Collection Lucien Treillard, Paris

Photographie n'est pas l'art, 1937
(Photography Is Not Art)
Portfolio with preface by André Breton.
Photogravure, 10 x 6 $^3/_8$"
Collection Timothy Baum, New York

Untitled, c. 1928
Commissioned by William Seabrook.
Vintage gelatin silver print, 4 $^1/_4$ x 2 $^{11}/_{16}$"
Collection Juliet Man Ray, Paris

Untitled, c. 1928
Commissioned by William Seabrook.
Vintage gelatin silver print, 3 $^1/_{16}$ x 4 $^3/_8$"
Collection Juliet Man Ray, Paris

Untitled, ladder and shoe, c. 1925
Modern gelatin silver print, 14 $^5/_8$ x 11 $^3/_{16}$"
Collection Juliet Man Ray, Paris

**Marjorie Seabrook with necklace attributed to fashion
designer Jean-Charles Worth, c. 1930**
Vintage gelatin silver print, 3 $^5/_8$ x 2 $^1/_4$"
Collection Juliet Man Ray, Paris

**Necklace attributed to fashion designer
Jean-Charles Worth, c. 1930**
Vintage gelatin silver print, 3 $^5/_8$ x 2 $^1/_4$"
Collection Juliet Man Ray, Paris

Bijoux, c. 1936
(Jewelry)
Modern gelatin silver print, 9 $^3/_4$ x 6 $^7/_8$"
Variant published in BAZAAR, August 1935
Collection Lucien Treillard, Paris

Diamonds yellow as flame, 1935
Modern gelatin silver print, 9 $^3/_8$ x 13 $^7/_8$"
Published in BAZAAR, August 1935
Collection Lucien Treillard, Paris

Variant of *Diamonds yellow as flame*, 1935
Modern gelatin silver print, 10 $^3/_8$ x 13 $^7/_8$"
Collection Lucien Treillard, Paris

Variant of *Diamonds yellow as flame*, 1935
Modern gelatin silver print from solarized negative,
9 $^3/_8$ x 13 $^{13}/_{16}$"
Collection Lucien Treillard, Paris

Variant of *Diamonds yellow as flame*, 1935
Modern gelatin silver print, 13 3/16 x 9 3/8"
Collection Lucien Treillard, Paris

Variant of *Diamonds yellow as flame*, 1935
Modern gelatin silver print, 11 5/16 x 8 7/8"
Collection Lucien Treillard, Paris

Hands painted by Picasso, c. 1935
Modern gelatin silver print, 11 x 14"
Collection Juliet Man Ray, Paris

Rayograph, 1927
Modern gelatin silver print, 10 3/8 x 8 11/16"
Collection Lucien Treillard, Paris

*Schiaparelli evening dress made of a print like the flag
of the Scottish Ogilvy Regiment in red, white, and green.*
BAZAAR, March 1940
Photomechanical reproduction, 12 1/16 x 17"
Collection International Center of Photography, New York

Untitled portrait, c. 1930
Modern gelatin silver print from solarized negative, 12 x 8 3/4"
Collection Lucien Treillard, Paris

Untitled, hands with Ponds cream, c. 1925
Vintage gelatin silver print, 3 5/16 x 2 5/16"
Collection Juliet Man Ray, Paris

Untitled, hands, c. 1925
Vintage gelatin silver print, 3 7/16 x 2"
Collection Juliet Man Ray, Paris

Untitled, woman and hands, c. 1925
Vintage gelatin silver print, 3 1/4 x 2 5/16"
Collection Juliet Man Ray, Paris

Untitled, study of hands, 1928
Modern gelatin silver print from solarized negative, 12 x 9"
Collection Lucien Treillard, Paris

Untitled, hand and lips, 1931
Modern gelatin silver print, 11 1/16 x 9 7/16"
Collection Lucien Treillard, Paris

The Bracelets, 1932
Model Jacqueline Goddard
Modern gelatin silver print from solarized negative, 11 1/16 x 8 7/16"
Collection Lucien Treillard, Paris

La mode au Congo, 1937
(Congo Fashion)
Vintage gelatin silver print, 11 1/4 x 8 5/8"
Published in BAZAAR, September 1937
Collection Juliet Man Ray, Paris

Adrienne Fidelin modeling African hat.
BAZAAR, September 1937
Photomechanical reproduction, 10 1/2 x 7 1/2"
Collection Juliet Man Ray, Paris

*The exposition of Bushongo and Bankutu head-dresses at
the Charles Ratton Galleries in Paris will surely have a
happy influence on fashion.*
Review by Paul Éluard.
BAZAAR, September 1937
Photomechanical reproduction, 13 x 9 1/4"
Collection Juliet Man Ray, Paris

*The most practical, humdrum, common-or-garden necessity
of life can be beautiful, if touched by the hand of the artist.*
BAZAAR, March 1937
Four-color photomechanical reproduction, 13 x 18 3/4"
Collection International Center of Photography, New York

*Maria Guy's garden-party hat of pale blue Panama
trimmed with hyacinths.*
BAZAAR, June 1937
Four-color photomechanical reproduction, 11 13/16 x 9 5/16"
Collection Juliet Man Ray, Paris

*A hunter's green felt from Reboux, up in back,
crushed with a forward dip.*
BAZAAR, November 1937
Photomechanical reproduction, 11 x 8 1/2"
Collection Juliet Man Ray, Paris

Istanbul. Reboux's black felt turban bound with velvet ribbons.
BAZAAR, November 1937
Photomechanical reproduction, 11 x 8 3/16"
Collection Juliet Man Ray, Paris

Minotaure, No. 3-4, Paris, 1933
D'un certain Automatisme du Goût.
(A Certain Automatism of Taste)
Article by Tristan Tzara with photographs by Man Ray.
Photomechanical reproduction, 12 1/2 x 9 1/2"
Collection Timothy Baum, New York

Untitled fashion photograph, c. 1935
Modern gelatin silver print, 10 5/8 x 15"
Collection Juliet Man Ray, Paris

Danses-Horizons, 1934
Vintage gelatin silver print, 9 x 11 3/4"
Published in *Minotaure*, Number 5, 1934-35
Collection Lucien Treillard, Paris

Explosante-fixe, 1934
(Stationary Explosion)
Modern gelatin silver print, 12 x 9 3/8"
Private Collection

Robe d'Alix, 1936
(Gown by Alix)
Modern gelatin silver print, 11 3/16 x 9 3/8"
Collection Lucien Treillard, Paris

Variant of *Robe d'Alix*, 1936
Modern negative gelatin silver print, 14 5/8 x 8 1/4"
Collection Lucien Treillard, Paris

Schiaparelli evening dress, c. 1937
Modern gelatin silver print, 15 3/16 x 10 5/8"
Published in BAZAAR, March 1937
Collection Juliet Man Ray, Paris

Untitled fashion photograph, 1936
Modern gelatin silver print, 14 7/16 x 11"
Collection Lucien Treillard, Paris

Untitled fashion photograph, 1936
Photomechanical reproduction, 15 x 11"
Collection Juliet Man Ray, Paris

*Black silk taffeta by Alix gored in back with
lavender, turquoise, rose and green.*
BAZAAR, February 1937
Photomechanical reproduction from solarized negative print with
color added during the off-set printing process, 10 9/16 x 7 7/8"
Collection Juliet Man Ray, Paris

Madness of the moment, Paquin's feather boa in all the colors of Harlem.
BAZAAR, February 1937
Photomechanical reproduction from solarized negative print with color added during the off-set printing process, 10 9/16 x 7 7/8"
Collection Juliet Man Ray, Paris

Vionnet's black silk organdie, shirred and cut till it becomes the ornament as well as the fabric.
BAZAAR, July 1936
Modern gelatin silver print from copy negative, 14 x 11"
Private Collection

Capes have come back in favor.
Femina, April 1934
Four-color photomechanical reproduction, 11 x 7 3/16"
Collection Juliet Man Ray, Paris

Brooding. Heavy. Black. Schiaparelli's magnificent cape emblazoned with gold.
BAZAAR, January 1937
Photomechanical reproduction, 10 15/16 x 8 7/16"
Collection Juliet Man Ray, Paris

Vionnet's crêpe (dinner dress) with a brooch of coral on the skirt.
BAZAAR, April 1936
Photomechanical reproduction, 12 13/16 x 8 3/8"
Collection Juliet Man Ray, Paris

Noël Coward's magnificent obsession: Miss Gertrude Lawrence. Norman Hartnell made the dress for Miss Lawrence's Shadow Play dance number - dusty pink tulle over pink satin.
BAZAAR, December 1936
Photomechanical reproduction from multiple print, 13 1/16 x 9 3/8"
Collection Juliet Man Ray, Paris

Schiaparelli's taffeta Pagliacci trousers in yellow with changeable orchid (colored) coat.
BAZAAR, January 1937
Photomechanical reproduction, 10 5/8 x 8 5/16"
Collection Juliet Man Ray, Paris

Lucien LeLong. The silk crêpes have subtle rare tones which we strive to reproduce here.
Femina, April 1934
Four-color photomechanical reproduction, 12 3/16 x 8 7/8"
Collection Juliet Man Ray, Paris

Alix has gone romantic, wildly, gloriously, with eighty-one yards of purple chiffon for the skirt and ten thousand Francs for the price. Ruching at the bottom in green, purple mousseline.
BAZAAR, March 1937
Photomechanical reproduction, 13 x 9 3/8"
Collection Juliet Man Ray, Paris

Black lace swallows flying all over the skirt of Vionnet's white organza.
BAZAAR, April 1937
Photomechanical reproduction, 11 1/4 x 8"
Collection Juliet Man Ray, Paris

Serpent of the Nile - Alix's headdress in fibre net, with a silk jersey skirt and taffeta tunic.
BAZAAR, April 1936
Photomechanical reproduction, 12 15/16 x 8 1/4"
Collection Juliet Man Ray, Paris

Mainbocher's triumph in black net with long tight sleeves.
Vintage gelatin silver print, 11 1/4 x 7 5/16"
Published in BAZAAR, March 1936
Courtesy Keith DeLellis, New York

Patou's languid white crêpe melting into pleats and swirled upward.
BAZAAR, February 1938
Photomechanical reproduction, 10 7/16 x 7"
Collection Juliet Man Ray, Paris

Untitled fashion triptych, c. 1936
Three vintage gelatin silver prints,
l: 12 1/2 x 6 1/4" c: 11 3/4 x 10 1/4" r: 12 1/2 x 6 1/2"
Triptych arrangement not attributed to Man Ray.
Center panel published in BAZAAR
Courtesy Keith DeLellis, New York

Louiseboulanger – a new cut and a new white crêpe satin splashed with pansy browns and yellows.
Vintage gelatin silver print, 11 9/16 x 8 11/16"
Published in BAZAAR, March 1936
Courtesy Keith DeLellis, New York

1937
Page layout from BAZAAR, April 1937
Photomechanical reproduction, 13 x 16"
Collection Juliet Man Ray, Paris

Marie Laure, Vicomtesse de Noailles, muse of a circle of writers and artists in Paris.
BAZAAR, January 1937
Photomechanical reproduction from solarized photograph, 10 1/2 x 7 3/4"
Collection Juliet Man Ray, Paris

Silken shadows. The darker, the sheerer.
BAZAAR, October 1935
Photomechanical reproduction, 13 x 18 3/4"
Collection Juliet Man Ray, Paris

Juliet Man Ray, c. 1945
Modern gelatin silver print, 11 1/8 x 9"
Collection Lucien Treillard, Paris

Padova's gold lamé sandal clasped thrice with jewels.
BAZAAR, January 1936
Photomechanical reproduction, 10 5/8 x 19"
Collection International Center of Photography, New York

Patou dinner dress of black crêpe trimmed with scalloped white organdie.
BAZAAR, April 1940
Photomechanical reproduction, 11 1/16 x 7 7/16"
Collection Juliet Man Ray, Paris

Schiaparelli - stiff pink ducharne satin, cut Empire with a train.
BAZAAR, March 1936
Photomechanical reproduction from multiply exposed negative, 10 13/16 x 8 1/16"
Collection Juliet Man Ray, Paris

Schiaparelli. Black Tie, the perfect printed black crêpe dress for little evenings.
BAZAAR, March 1936
Photomechanical reproduction, 10 13/16 x 8 1/16"
Collection Juliet Man Ray, Paris

Schiaparelli. Black skirt, pink plaid jacket and a soft felt derby inspired by (politician) Al Smith.
BAZAAR, March 1936
Photomechanical reproduction, 10 $^{15}/_{16}$ x 8 $^{3}/_{16}$"
Collection Juliet Man Ray, Paris

The Bride – Schiaparelli's dress of heavy white ribbed rayon ottoman.
BAZAAR, April 1936
Photomechanical reproduction, 11 $^{3}/_{4}$ x 9"
Collection Juliet Man Ray, Paris

Advertisement for Bergdorf Goodman
BAZAAR, February 1937
Photomechanical reproduction, 13 x 9 $^{1}/_{2}$"
Collection Juliet Man Ray, Paris

This young gray head. The glamour is spectacular in a way that the bewigged ladies of the eighteenth century understand very well. The secret is simple. White hair, lavender rinsed.
BAZAAR, February 1937
Photomechanical reproduction from solarized photograph,
7 5/6 x 9 $^{1}/_{4}$"
Collection Juliet Man Ray, Paris

Pale, pink and fragile - Annek's nightgown, add a slip and it becomes an evening dress.
BAZAAR, October 1936
Photomechanical reproduction, 12 $^{1}/_{4}$ x 8 $^{5}/_{16}$"
Collection Juliet Man Ray, Paris

Pink and blue chiffon nightgown by Annek, 1936
Vintage gelatin silver print, 8 $^{5}/_{16}$ x 6 $^{1}/_{2}$"
Courtesy Keith DeLellis, New York

Olga Hitrova's diaphanous gift to the evening in clear aquamarine.
BAZAAR, October 1936
Photomechanical reproduction, 12 $^{1}/_{4}$ x 8 $^{11}/_{16}$"
Collection Juliet Man Ray, Paris

The line we strive for – a smooth curve over the hips.
BAZAAR, September 1935
Photomechanical reproduction, 13 x 9 $^{5}/_{16}$"
Collection Juliet Man Ray, Paris

Rise from bed like a mermaid in a sea-shell-pink chiffon night gown.
BAZAAR, July 1937
Photomechanical reproduction, 12 $^{13}/_{16}$ x 7 $^{3}/_{10}$"
Collection Juliet Man Ray, Paris

Man Ray, who has been painting in Hollywood, momentarily returns to his former medium, photography, with this extraordinary study of a woman's face for the beauty issue.
BAZAAR, November 1942
Photomechanical reproduction, 11 $^{3}/_{8}$ x 8 $^{15}/_{16}$"
Collection Juliet Man Ray, Paris

Self-portrait, 1932
Modern gelatin silver print from solarized negative,
11 $^{1}/_{16}$ 0 7 $^{1}/_{2}$"
Collection Lucien Treillard, Paris